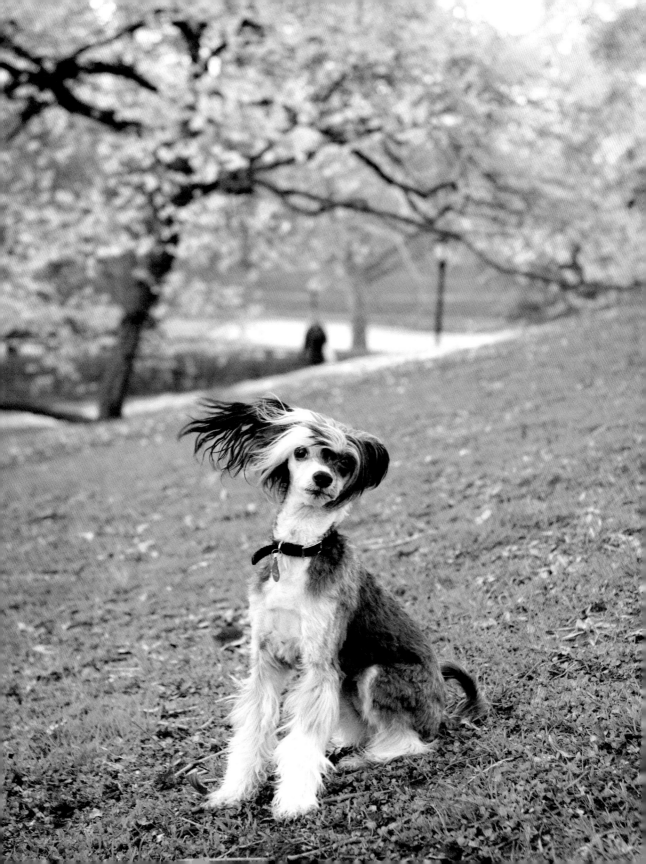

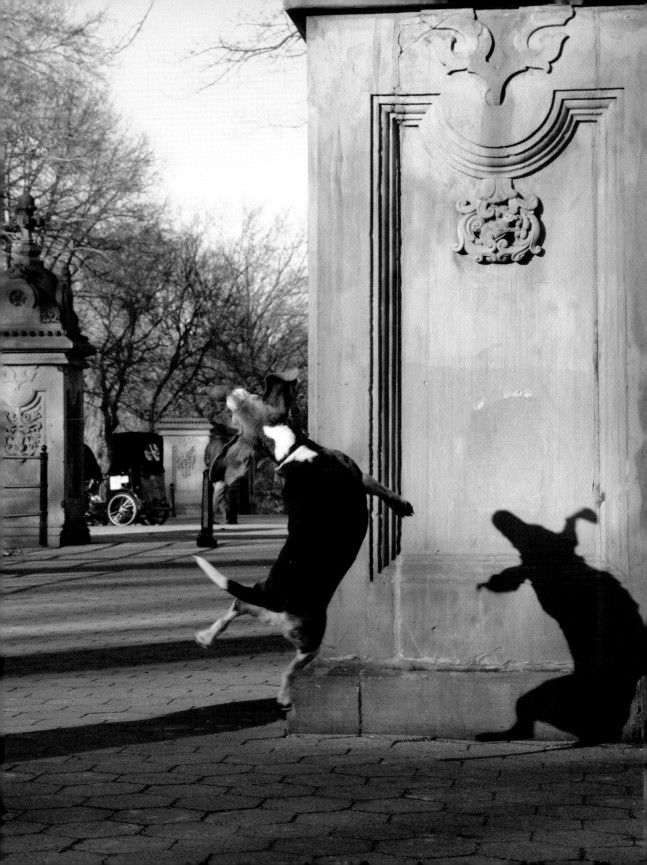

The DOGS of CENTRAL PARK

FRAN REISNER

Universe

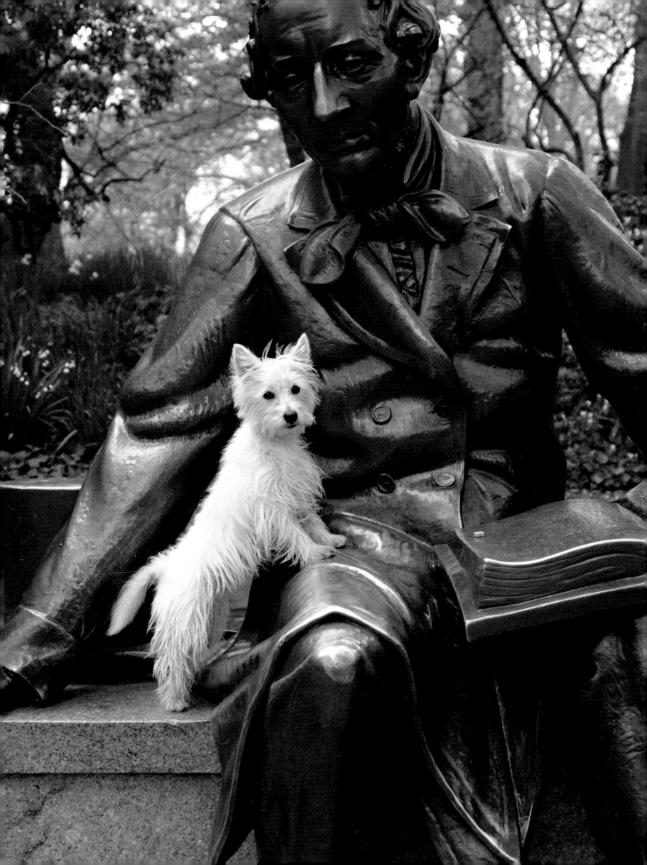

PREFACE

DOGS AND THEIR HUMAN COMPANIONS are among the most loyal visitors to Central Park. Like mail carriers, "neither snow nor rain nor heat nor gloom of night" stays them from their twice-daily visits to the Park. They are among the 35 million visitors to Central Park each year. They are also unquestionably one of the Park's stellar attractions. Let Maine have its moose and Florida its manatees! In the heart of Manhattan, it takes a dog to understand the beauty of autumn leaves, the thrill of new-fallen snow, and the promise of flowers on a rainy spring day.

Many of the Park's users are involved with Central Park PAWS, the community of dog owners that works with the Central Park Conservancy to help the Park and to make sure that dogs don't damage fragile landscapes or harass wildlife. And as these pages inadvertently confirm, their urban lives—owners and pets—are much better thanks to the Conservancy's exquisite care of Central Park's green expanses and treasures. Central Park has never looked better. And it wouldn't be complete without one of its most appealing and varying features—the dogs who know it well.

Groucho Marx once said, "Outside of a dog, a book is man's best friend. Inside of a dog it's too dark to read." *The Dogs of Central Park* offers the pleasures of both.

—ADRIAN BENEPE
COMMISSIONER
NEW YORK CITY DEPARTMENT
OF PARKS & RECREATION

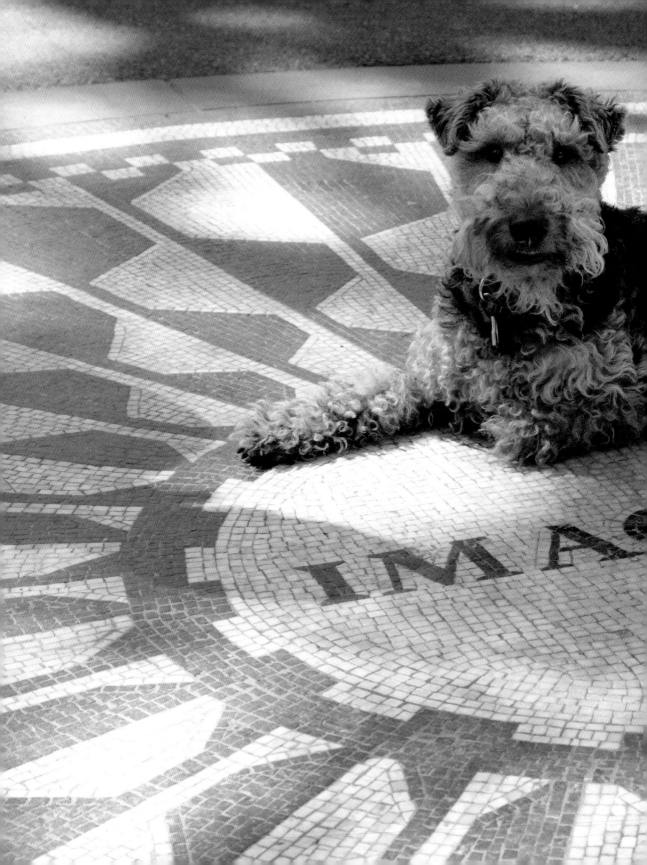

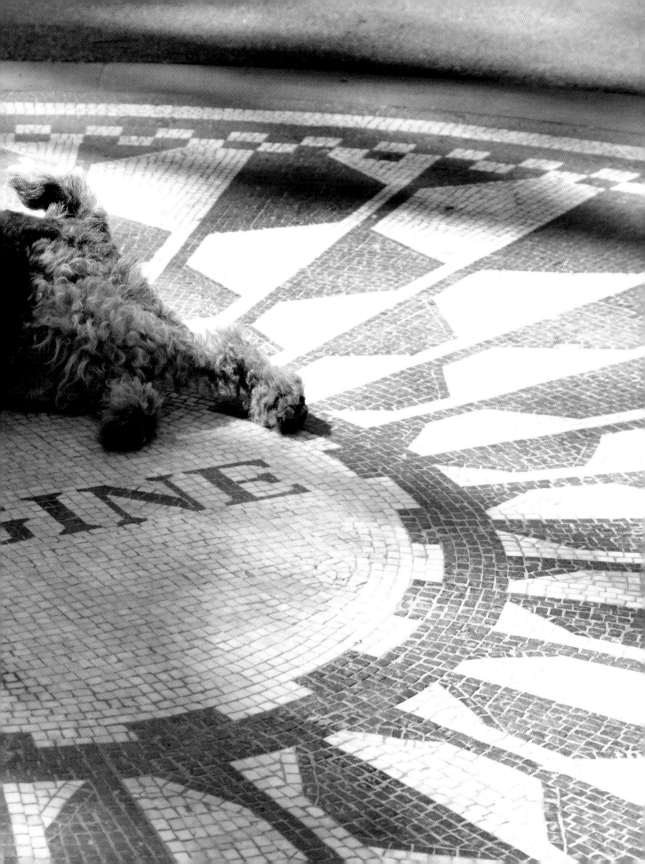

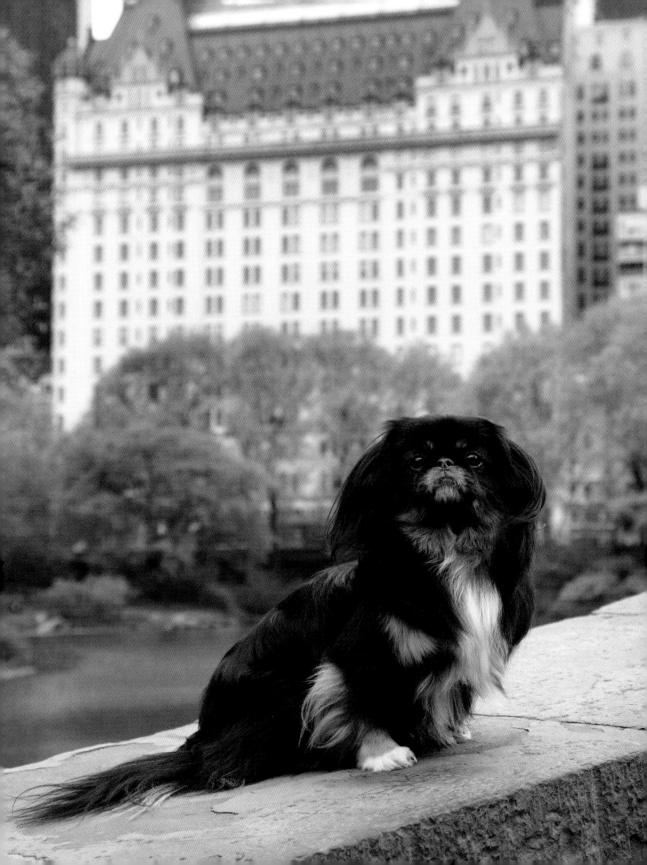

INTRODUCTION

BEFORE THIS JOURNEY BEGAN I had been to New York City only twice, but remember being captivated by Central Park and those who frequent it from the moment I walked under its canopy of trees. You can't help but be taken by the vastness of the park alone, but the experience of walking through this amazing place, glancing beyond the trees at the New York City skyline, and enjoying the iconic details, from Bethesda Fountain to Belvedere Castle and beyond, is simply magical. When an assignment took me to New York City in the spring of 2008 I was thrilled to find the park in full bloom, and left my hotel with camera in hand early the following morning to capture Central Park in all its splendor and glory. What I saw as I crested the first hill on my path was unforgettable: dogs, everywhere! Big dogs, little dogs, and many breeds I'd never seen before. The first group I came upon stopped me in my tracks as I watched a small black dog with a red ball in his mouth running at lightning speed, followed by several other dogs of similar size chasing after him; not once did they get out of order. As I stood watching I noticed the owners were standing in the middle of the rumpus, chatting among themselves. It was clear that this was their daily routine. The dogs romped gleefully like children at a playground, and I sensed that if you listened hard enough you could almost hear them laughing. From that moment on, every path I wandered down led me to one hilarious or amazing scene after another. I have never seen so many dogs in one place, and was taken by their eclectic mix and how wonderfully socialized they were. I was bewitched by their spirits, and the further I walked the more so I became. There was no doubt that this unique community of dogs, coming together in this iconic park, was worth capturing.

This journey brought me back to New York City seven times over the course of nearly two years. I spent thirty-five days in the park, hiking hundreds of miles, sometimes in extreme weather conditions ranging from blustering snowstorms to scorching summer heat to torrential downpours, and not once did I grow tired of observing these dogs. Their stories are as diverse as the hounds themselves: Lenny, the world traveler; Scheki, the three-legged beauty who was rescued from Israel; Charley, the certified Delta Dog; Daisy, whose eyes inspired Roberta Flack to stop and sing to her; Gertrude, a pit bull mix who was rescued by Bernadette Peters.

What struck me most is the diversity of the dogs themselves, a cornucopia of purebred champions and rescue mutts. When asked what breeds I saw most often, I thought of the Golden Retrievers, Shepherds, and Poodles. But if you could call them a breed, it's the mixed breeds, many from all over the world, who take the lead in sheer numbers. Their stories are as diverse as they are, and bring to mind the melting pot of New York itself. One can't help but be touched by the tales of these dogs and, in some cases, the lives they were rescued from. It's hard not to be inspired by the numerous rescue organizations in and around New York City. It is with a huge amount of respect that I dedicate this book to those who give so selflessly of their time and efforts on behalf of the millions of helpless animals around the globe.

—FRAN REISNER

THE MALL

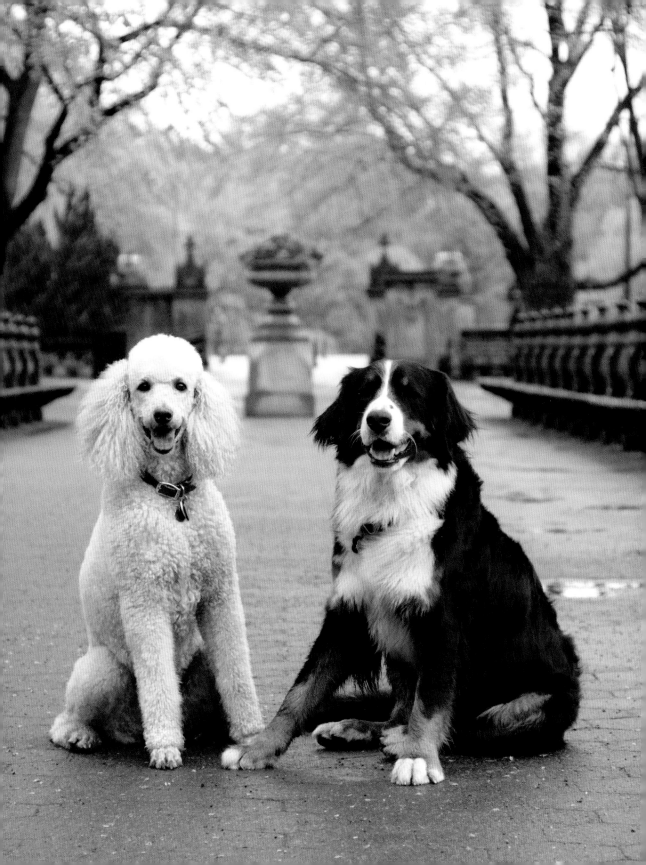

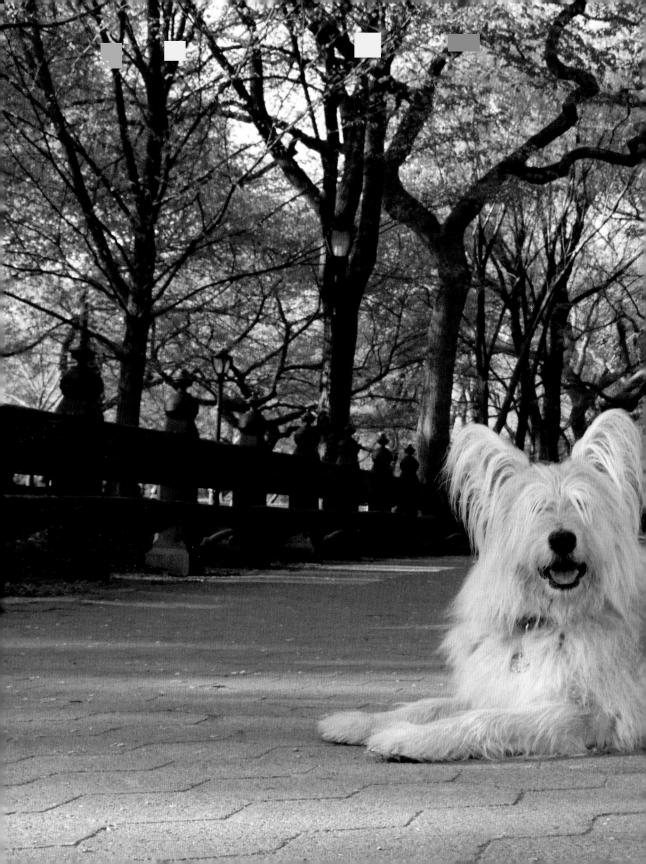

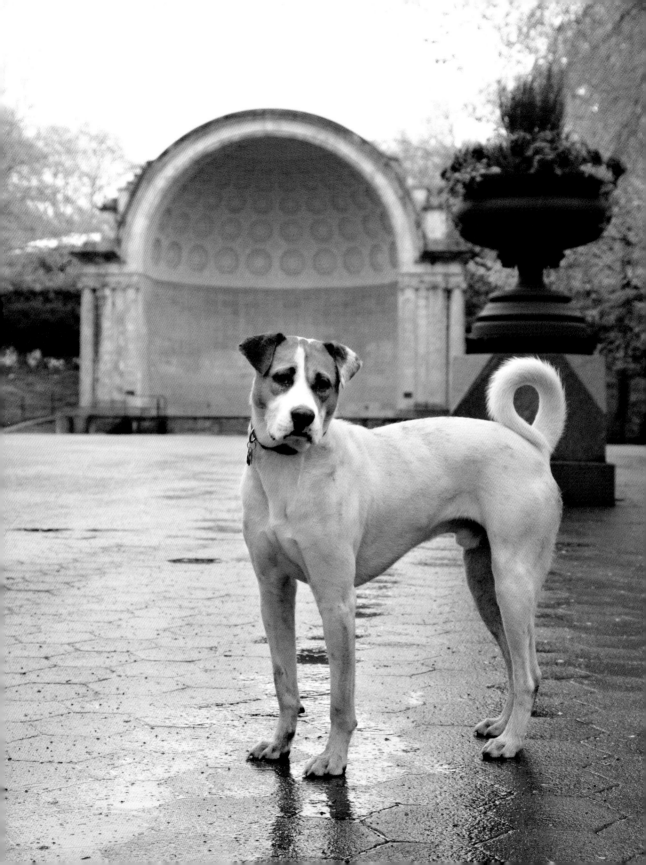

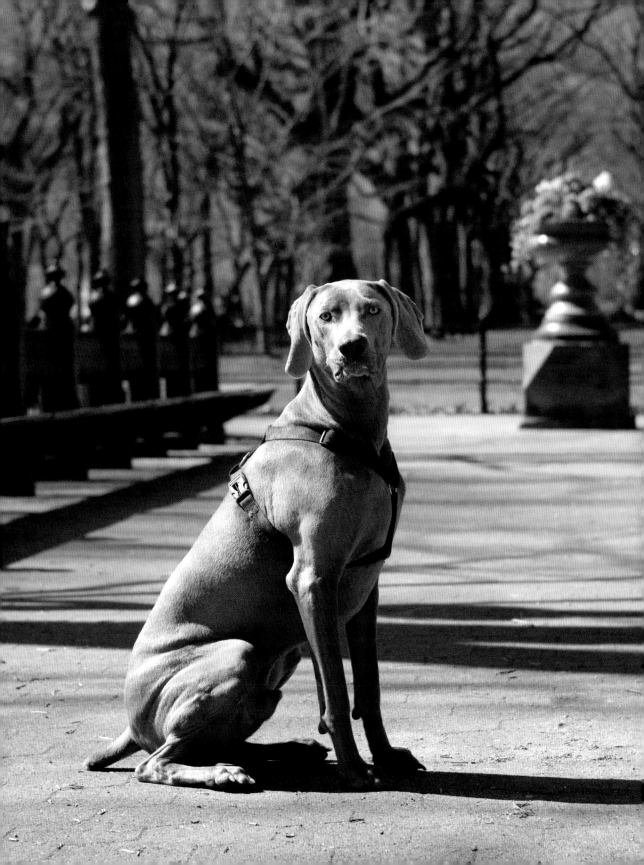

Central Park's planners Olmstead and Vaux asserted that a grand promenade was an essential feature of an urban park, and I'm sure many of the city's dogs would agree. On any day of the week, in every kind of weather, the Mall is filled with dogs and their human chaperones, strolling underneath the canopy of elm trees, which provide shade on hot days and protection from inclement weather on rainy ones. For some dog owners, a stroll through the Mall is part of their daily routine; others stop along the way to enjoy the statues of famed writers as if it is their first time in the park. The dogs, however, have their own agendas: looking out for squirrels, delighting in the cornucopia of scents, and making friends with the other dogs and people they encounter. I met Obie *(previous page, left)* one drizzly morning in front of the Bandshell at the southern end of the Mall. A Boxer-Pointer mix, Obie was rescued in Georgia and adopted from the North Shore Animal League, a rescue center on Long Island. When I saw him, Obie was soaking wet and having the time of his life, greeting every dog or human who happened by.

I was told by his owner that "The Duke of West Sixty-Ninth Street" *(previous page, right)* a devilishly handsome Weimaraner, enjoys long walks in the park, romantic comedies, and curling up on the couch with a fresh bone.

I also spotted Lenny *(opposite)* on the Mall, and hurried across the icy pavement to catch up with him. I discovered that this beautiful Golden Retriever was born in Austria and has traveled the world with his owners, opera singer Luca Pisaroni and his wife, Catherine. Lenny loves Central Park, especially when it's covered in snow.

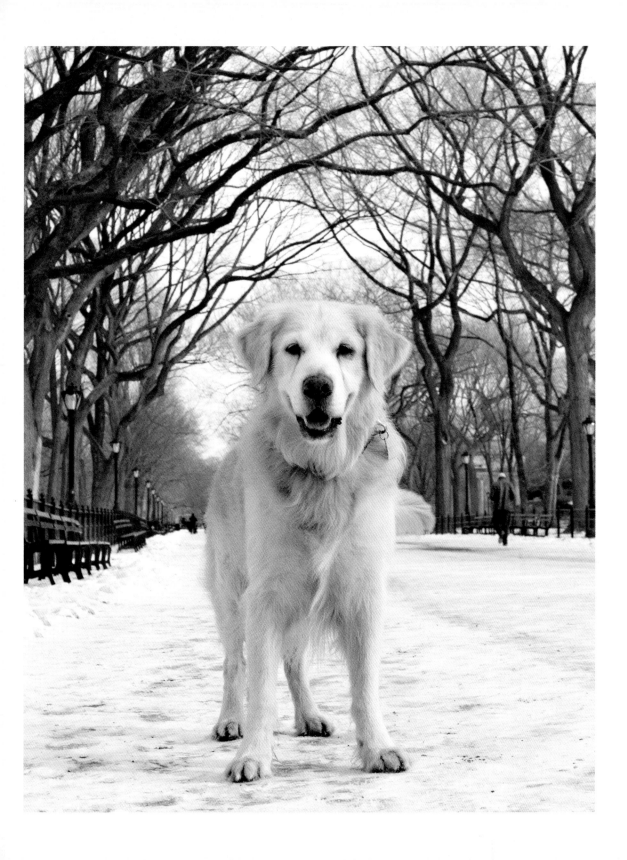

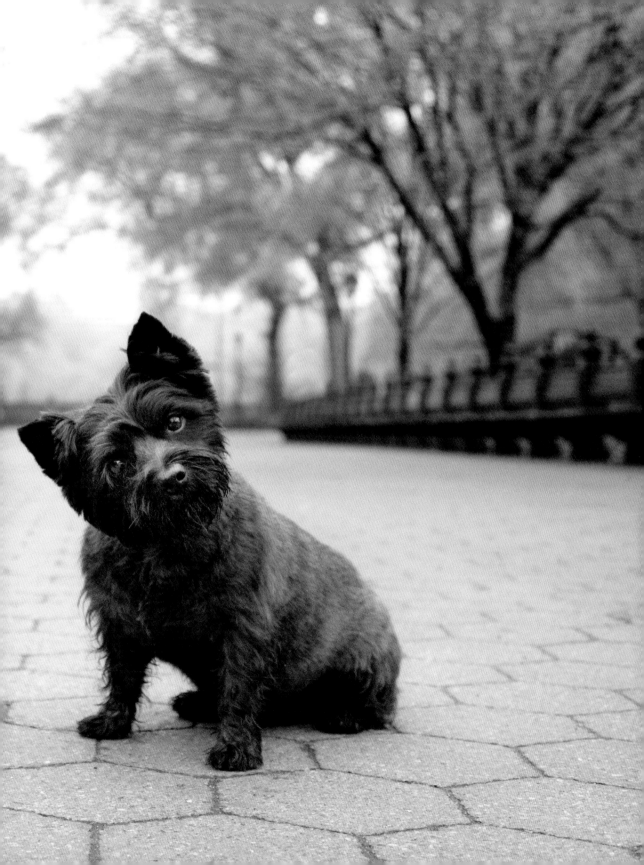

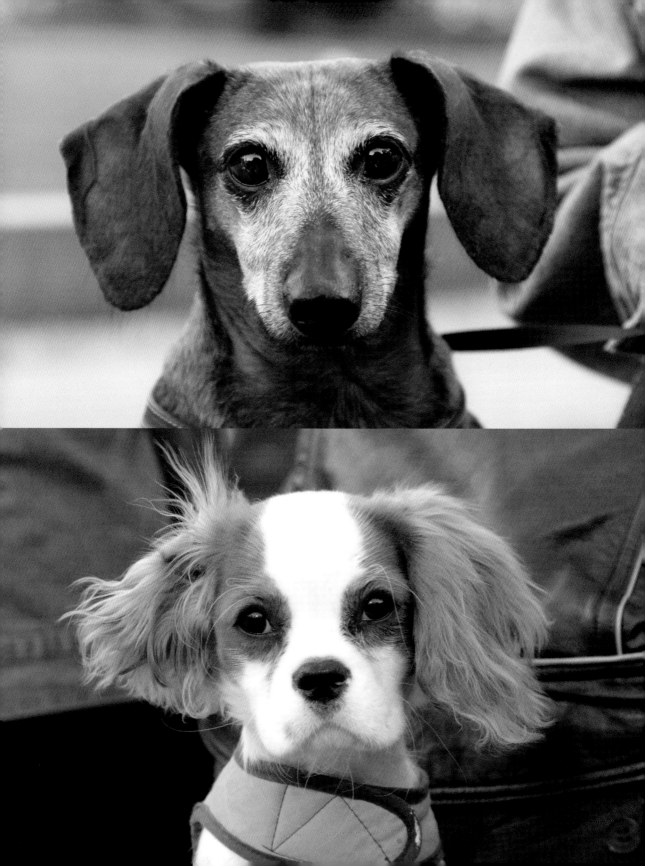

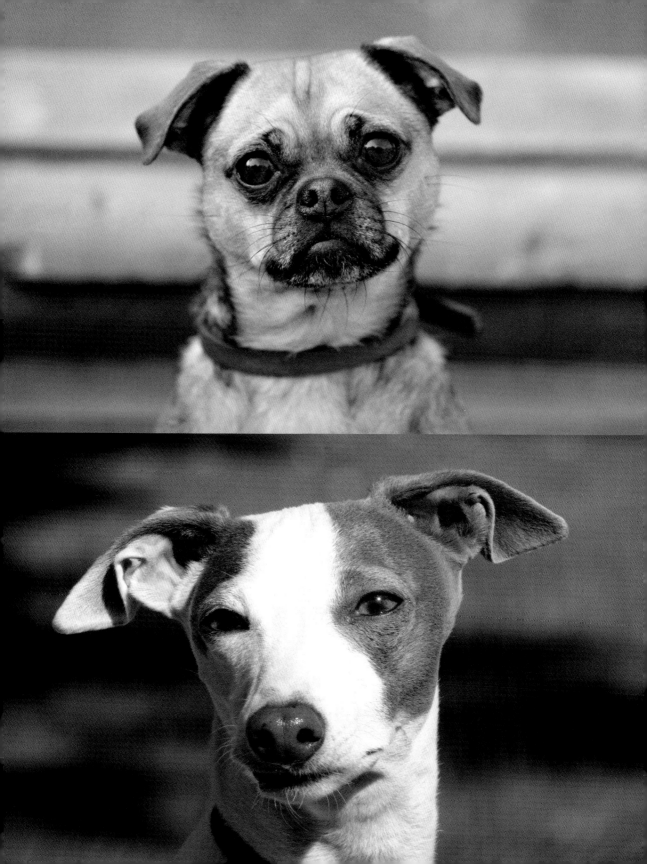

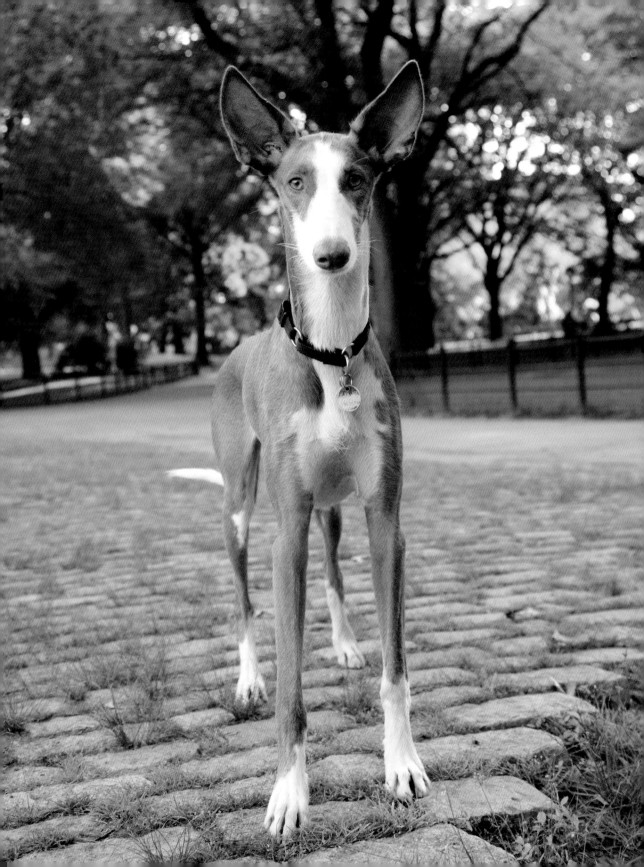

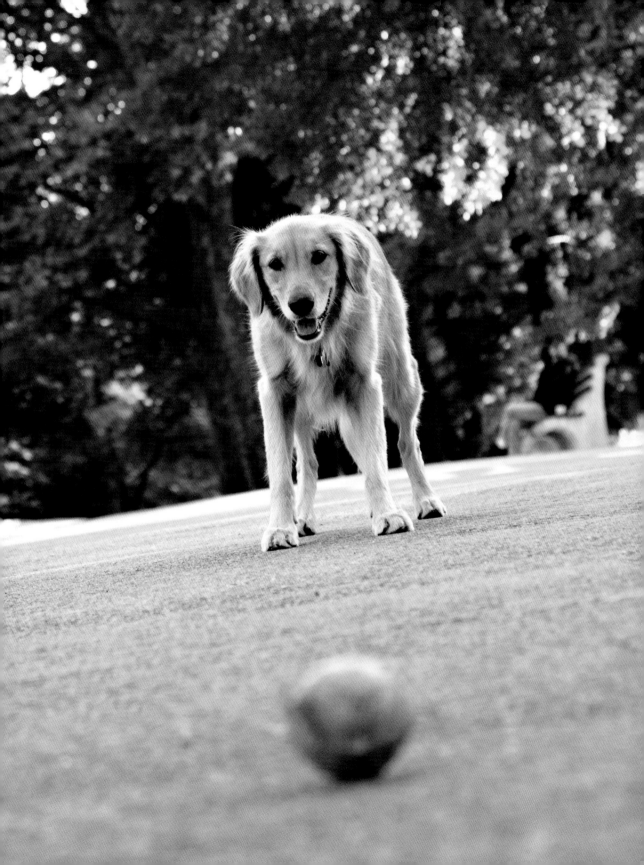

BELVEDERE CASTLE

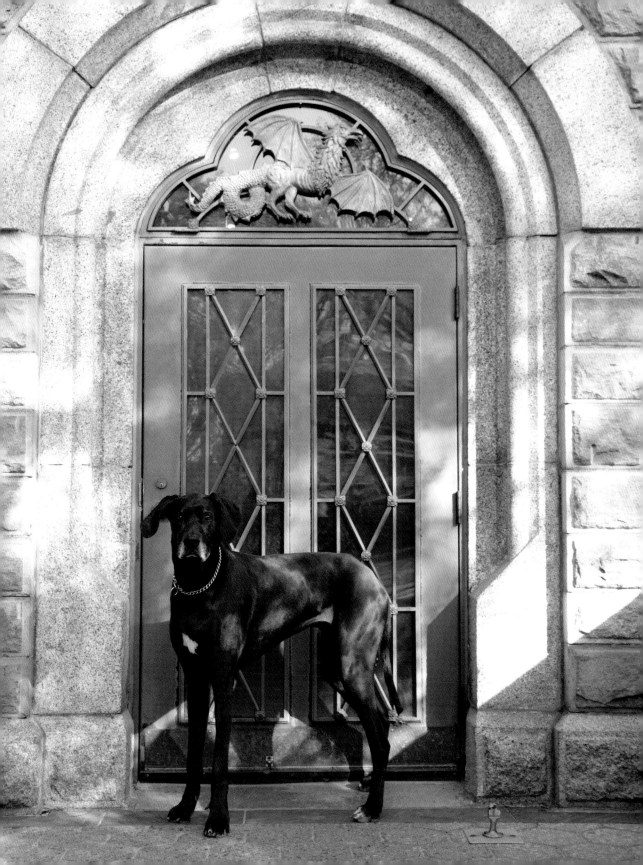

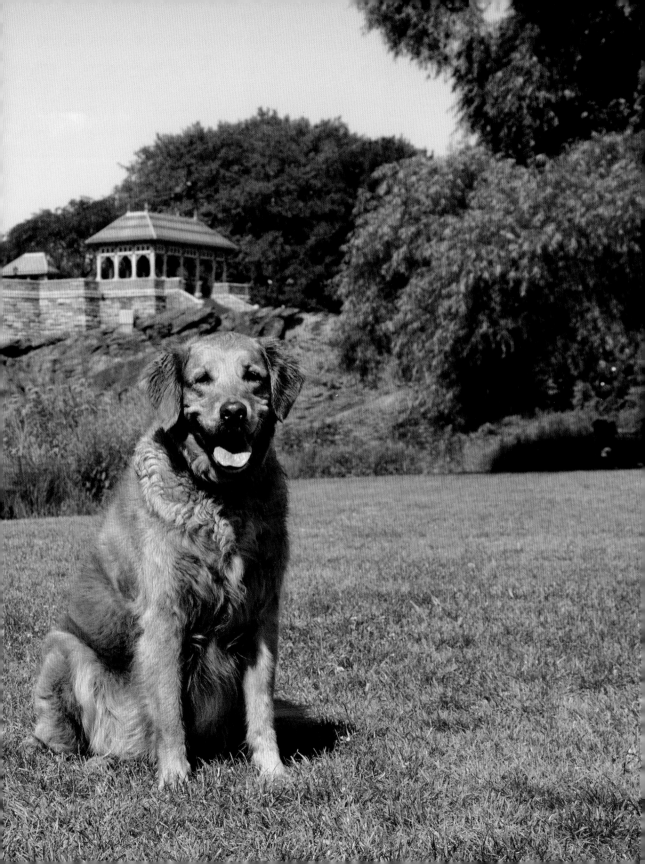

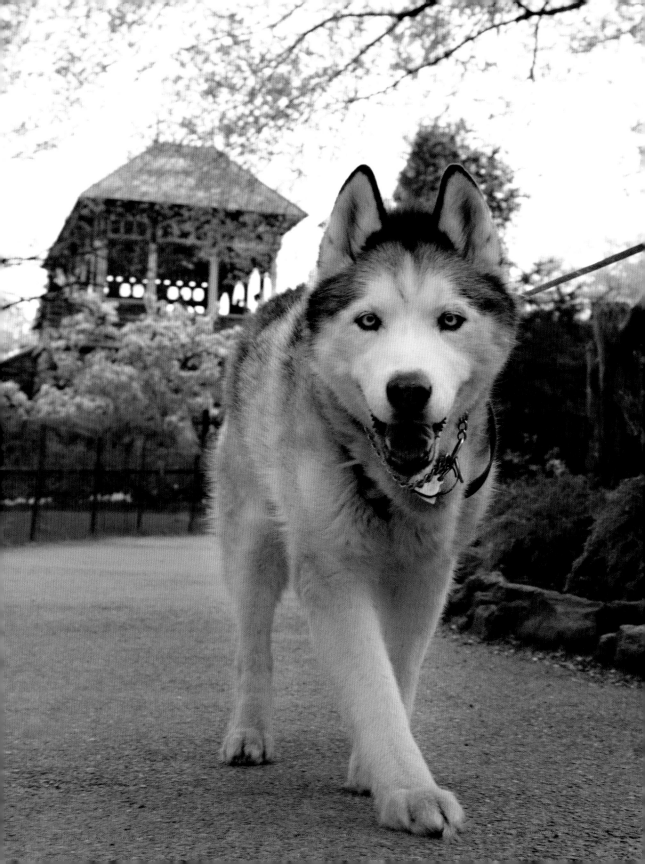

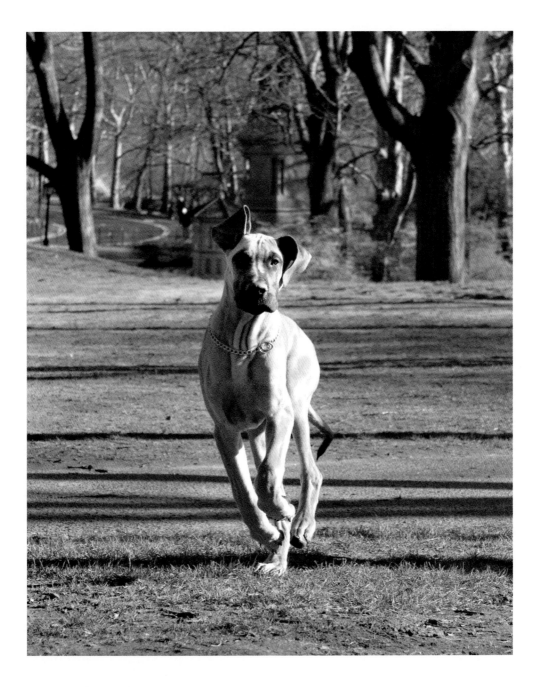

I was very touched and often amused by the relation-
ships between the dogs and their owners. All beamed
with pride as they shared stories about these dogs;
their silly antics, favorite things, and how they found
one another. In most cases it was clear that their lives
were greatly enhanced by their beloved pets.

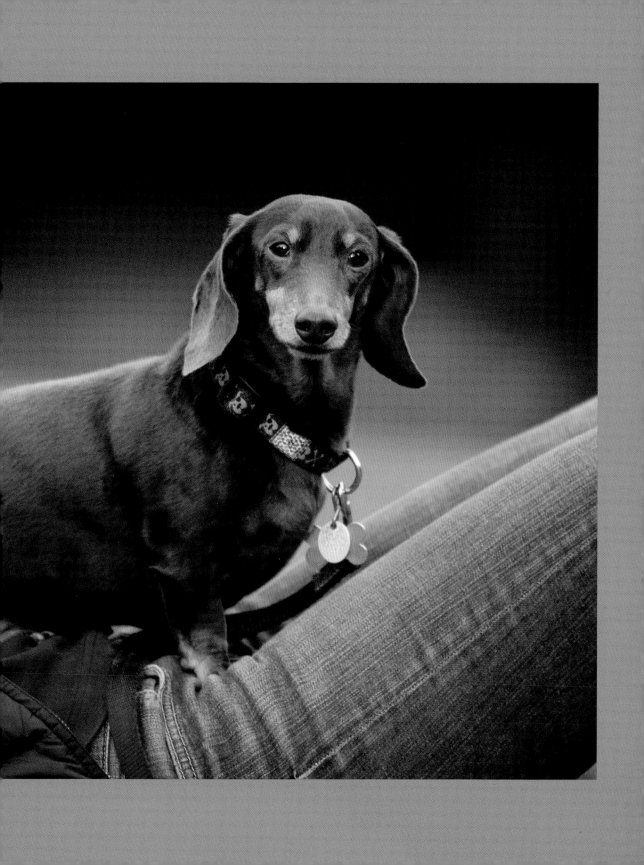

Perhaps it should come as no surprise that New York's reputation as a cross-cultural melting pot extends to the canine population. Visitors from other parts of the country will be struck by the amazing diversity of New York's dogs, especially in Central Park. Every breed and mix imaginable is represented here—from champion lines to multi-breed rescues, from teacup Chihuahuas to the greatest Great Danes, and everything in between.

I've also met dogs who have come to New York from all over the world: Germany, Ireland, France, Austria, Bermuda, Israel, Canada, and England. Like the rest of the tourists, dogs are wowed by the epic backyard that is Central Park.

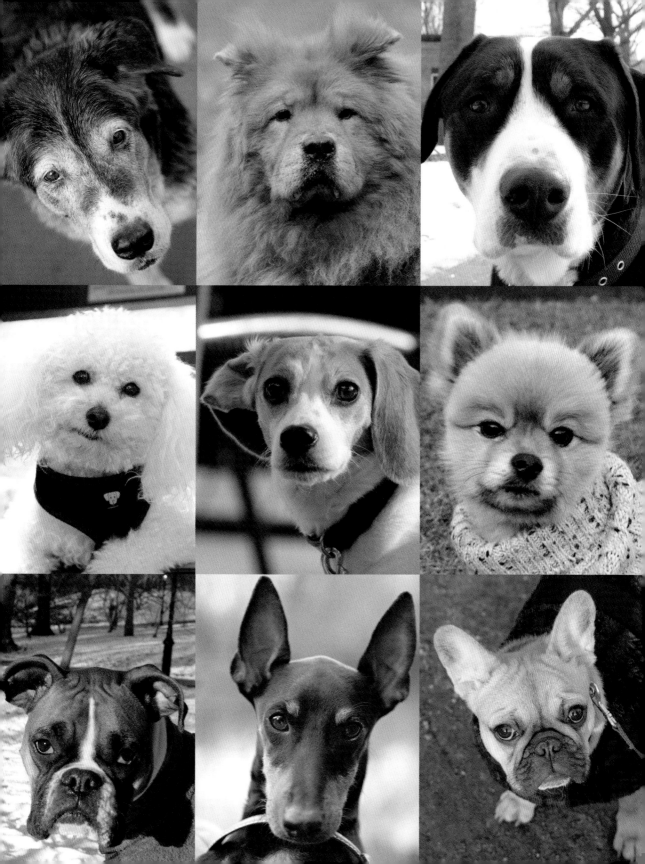

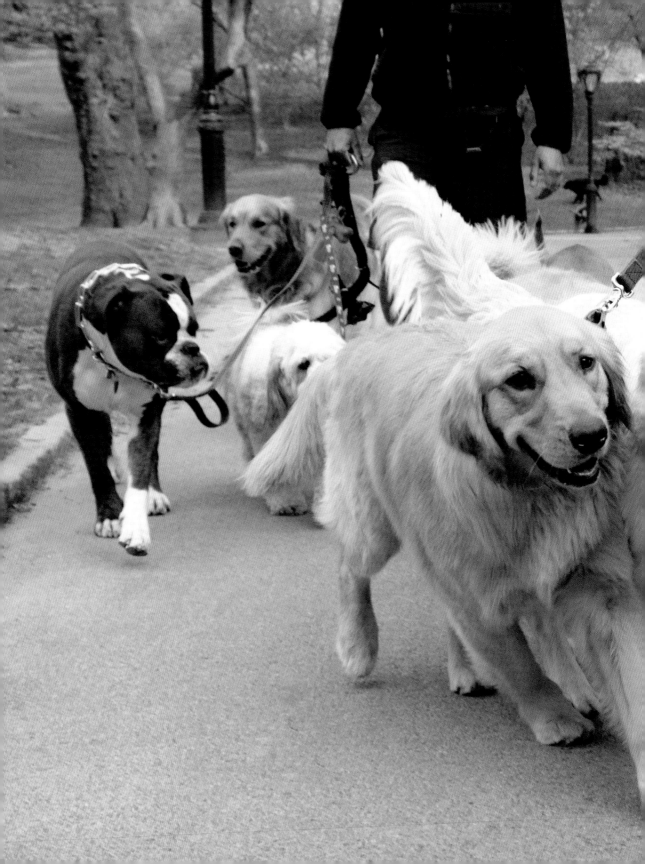

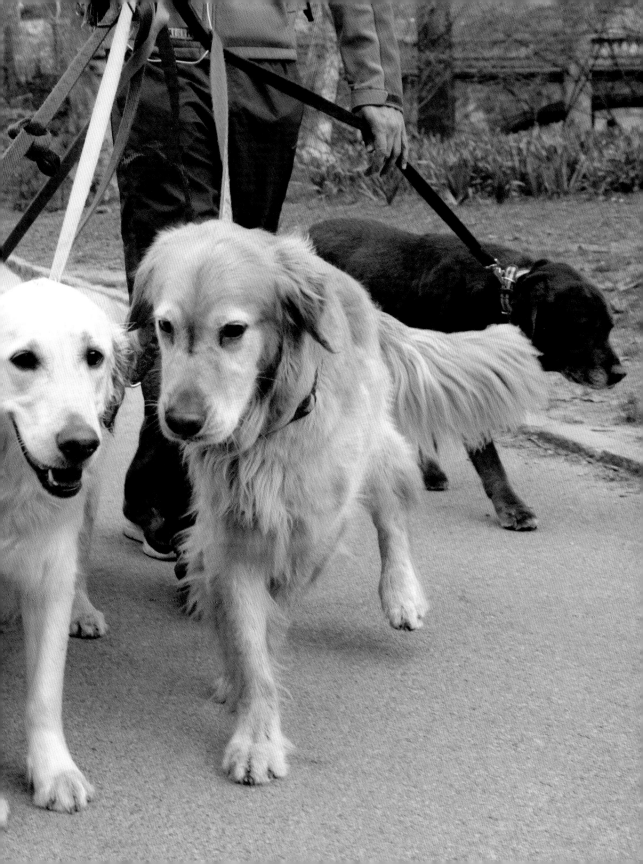

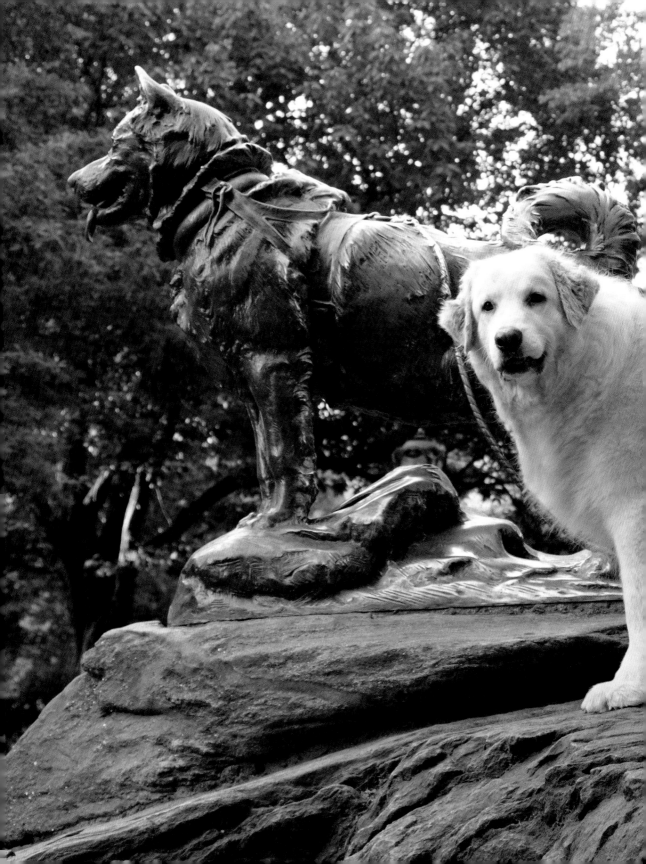

THE BOAT HOUSE

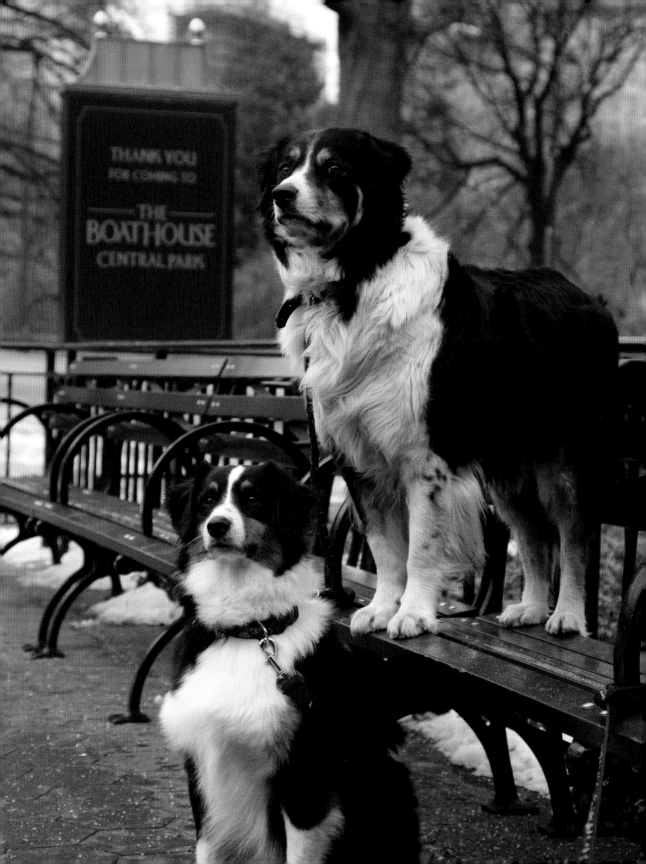

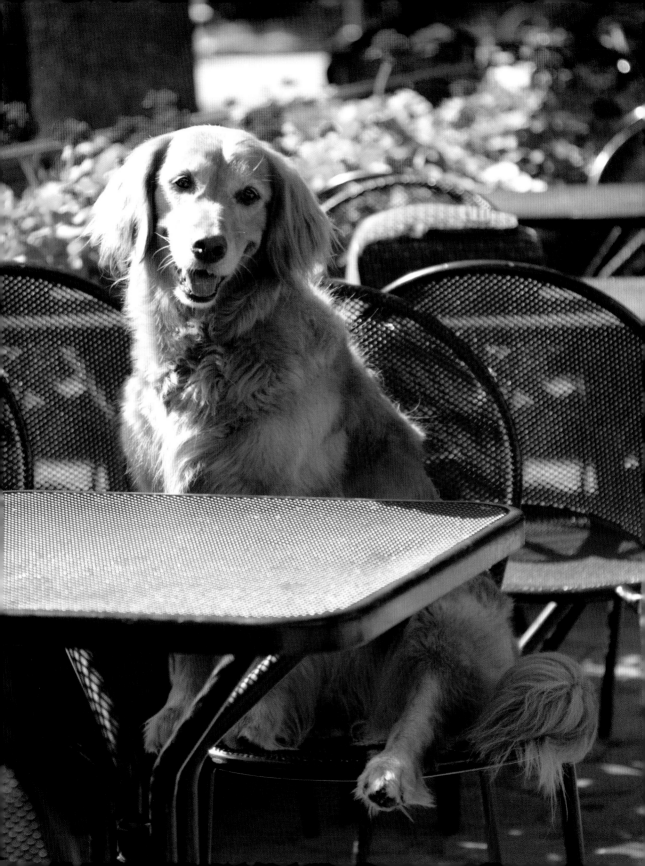

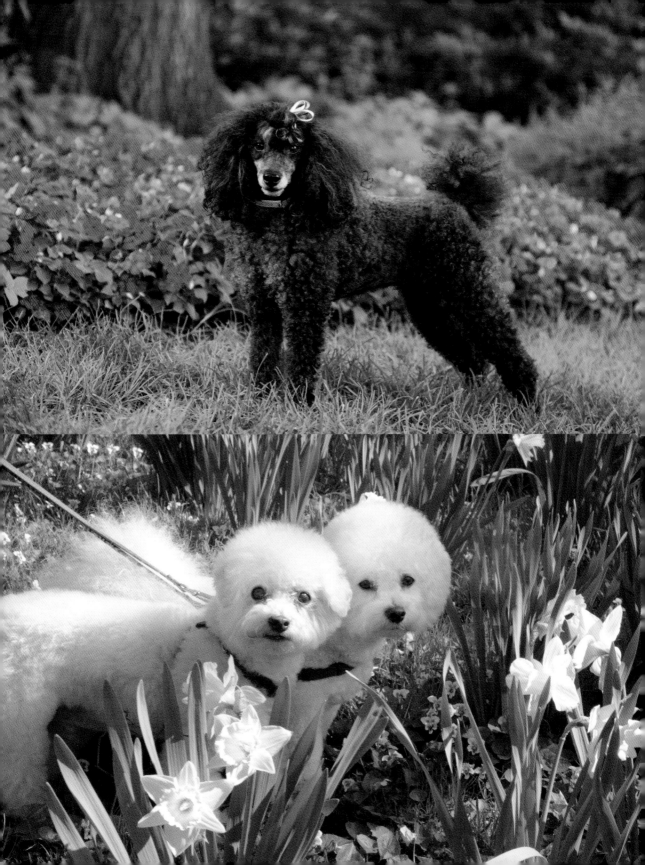

A common refrain among owners of rescue dogs is, "I thought I was rescuing this dog, but it turned out he rescued me!" Central Park is filled with owners who proudly recount stories of how they rescued their dogs, and tout their mixed-breed provenance. Gertrude *(right)* was rescued by Broadway star Bernadette Peters. Bernadette is very active in fundraising for animal rescue and is a vocal supporter of the cause, as are many other celebrities who live around Central Park.

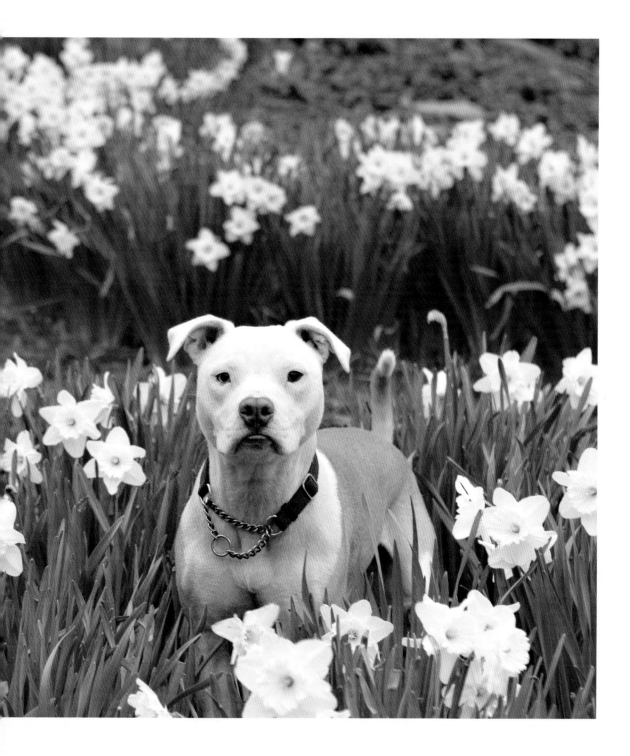

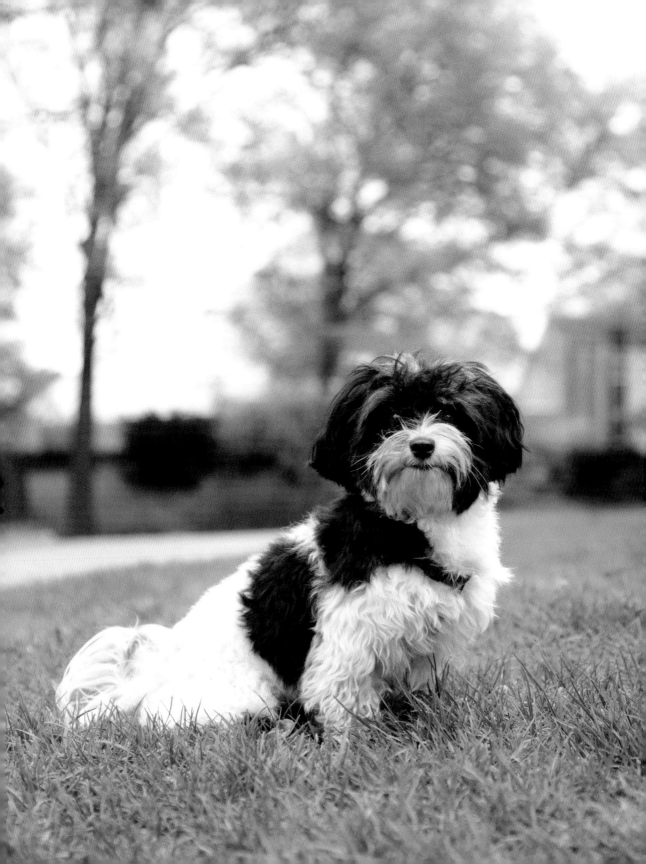

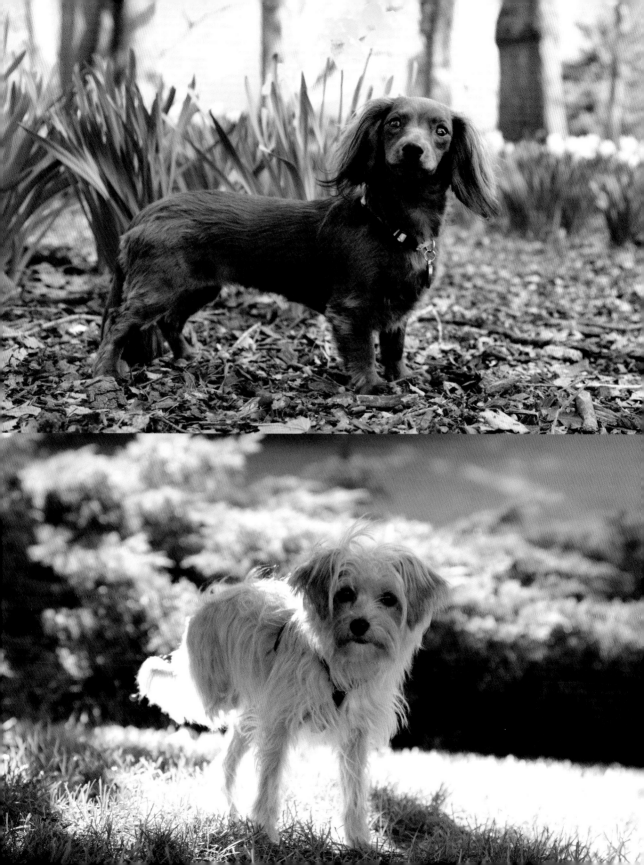

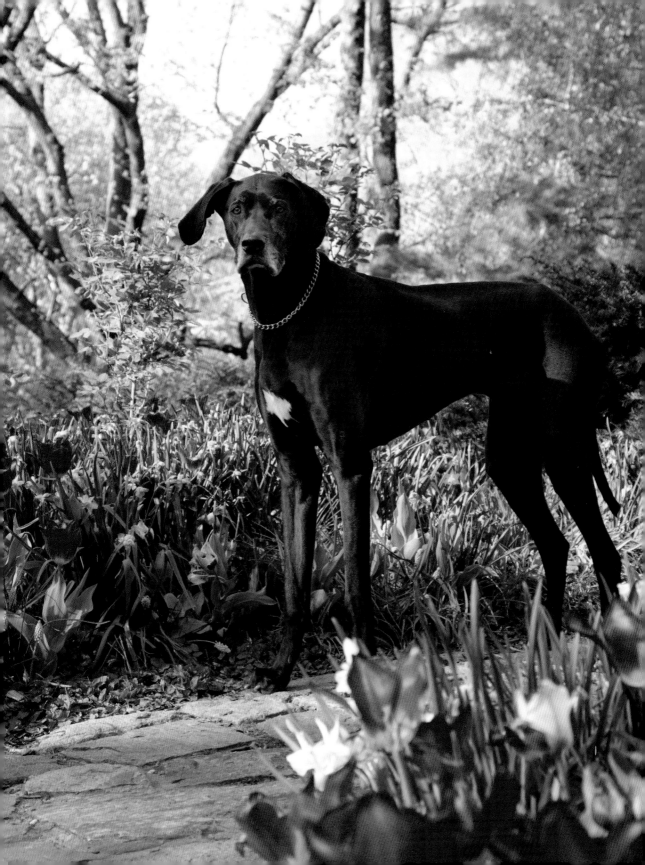

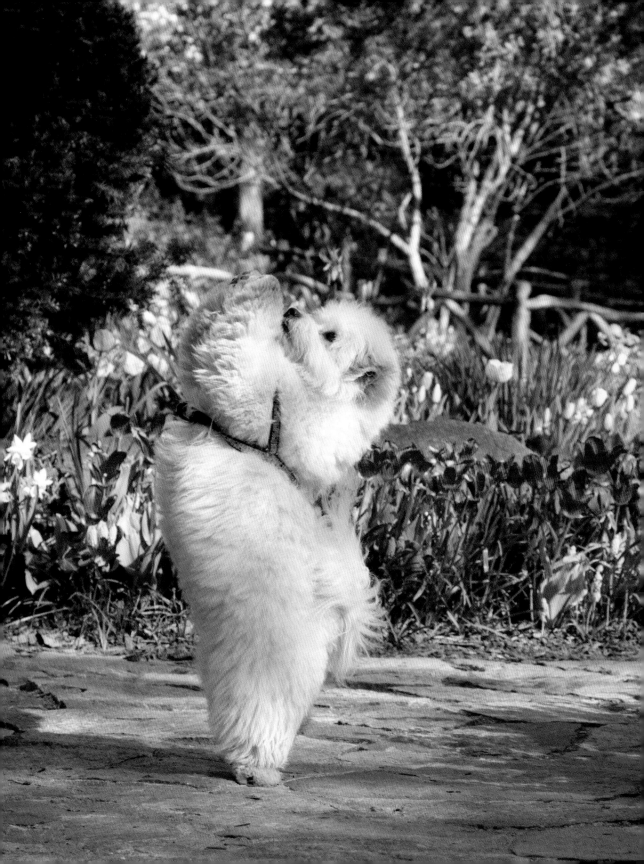

The dogs that call Central Park their playground are envied by owners around the world. Imagine daily strolls past Balto, or along the paths of Shakespeare Garden! But the "regulars" don't care about where they are nearly as much as they care about who they are with: the other dogs they see on their walks, and the humans that pay attention to them. And of course, they're always up for a treat. It's common to see several dogs outside the doors to the Boathouse restaurant waiting for their owners to bring out a little bit of bacon!

Oreo *(previous page, left)*, an adopted Great Dane, is truly a gentle giant. Every time I saw him in the park, I was as taken by his sweet disposition as I was impressed by his tremendous size.

Brinkley *(previous page, right)* is a mischievous Coton de Tuléar. His escapades inspired his owner to start a blog called Stinkley Brinkley. I discovered one night that he lives up to his nickname; while I ate dinner with his owner, Brinkley ate my hat.

This lovely couple, Mikimoto and Gem *(opposite, left and right, respectively)* are retired "Best in Show" Standard Poodles. Their daily stroll takes them past the beloved statues of Balto, Beethoven, Hans Christian Andersen, and Alice in Wonderland.

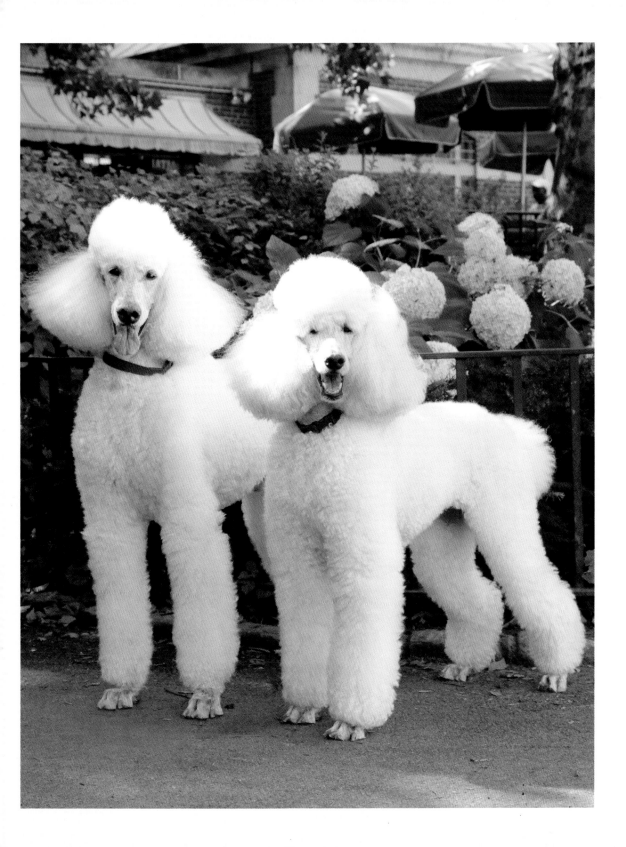

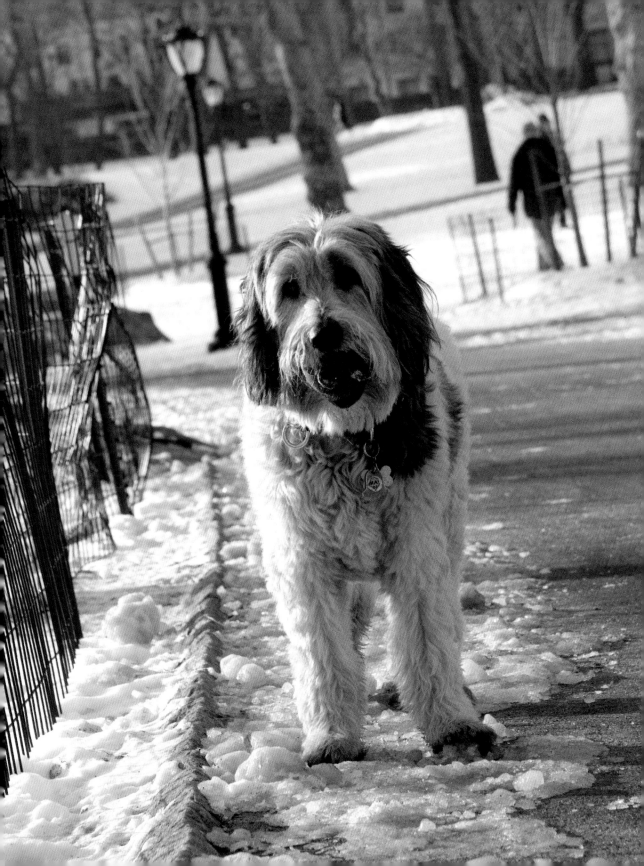

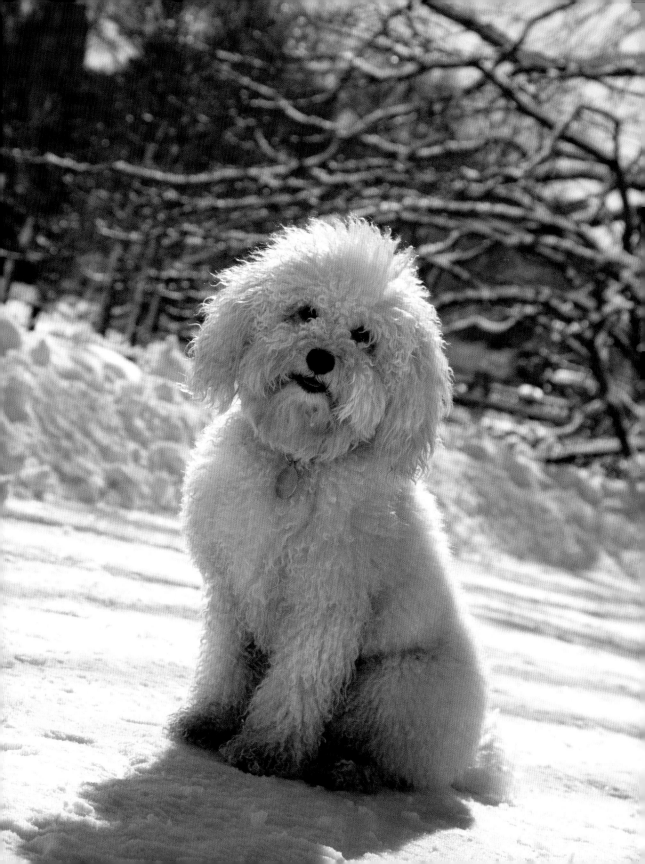

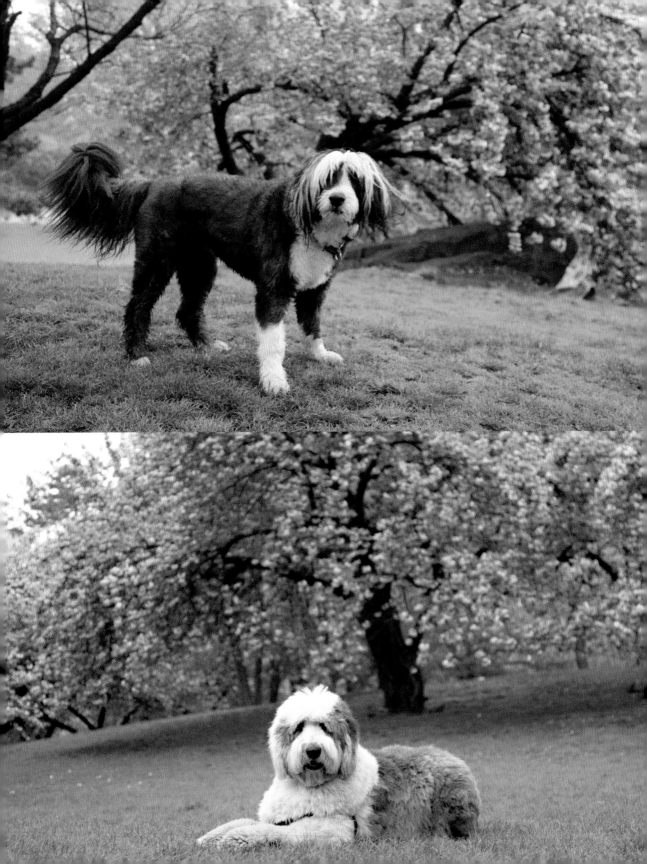

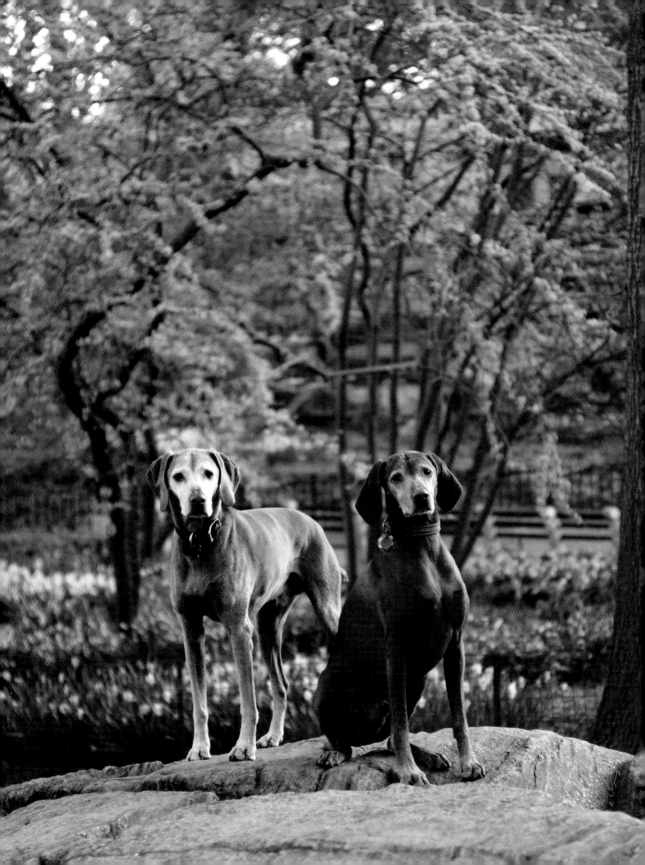

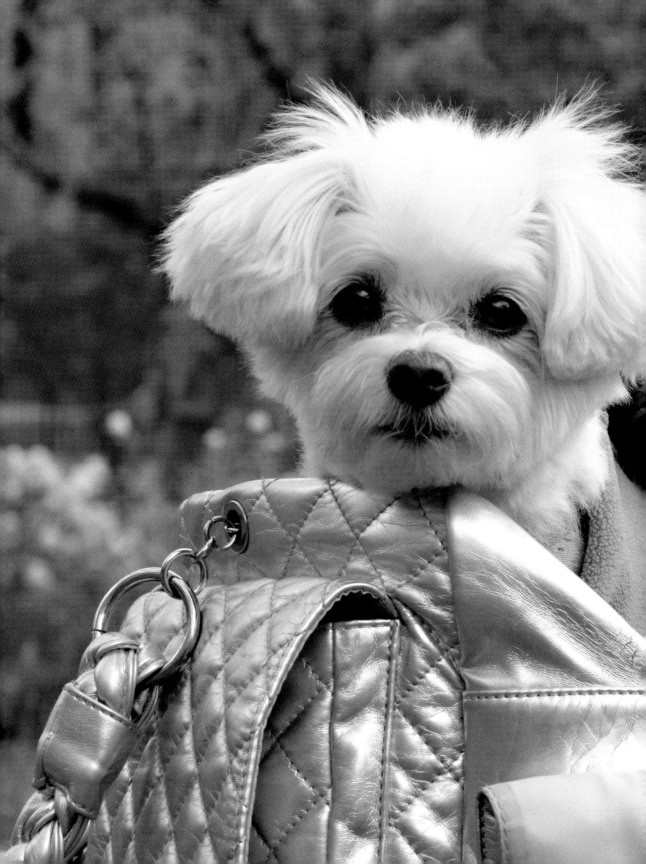

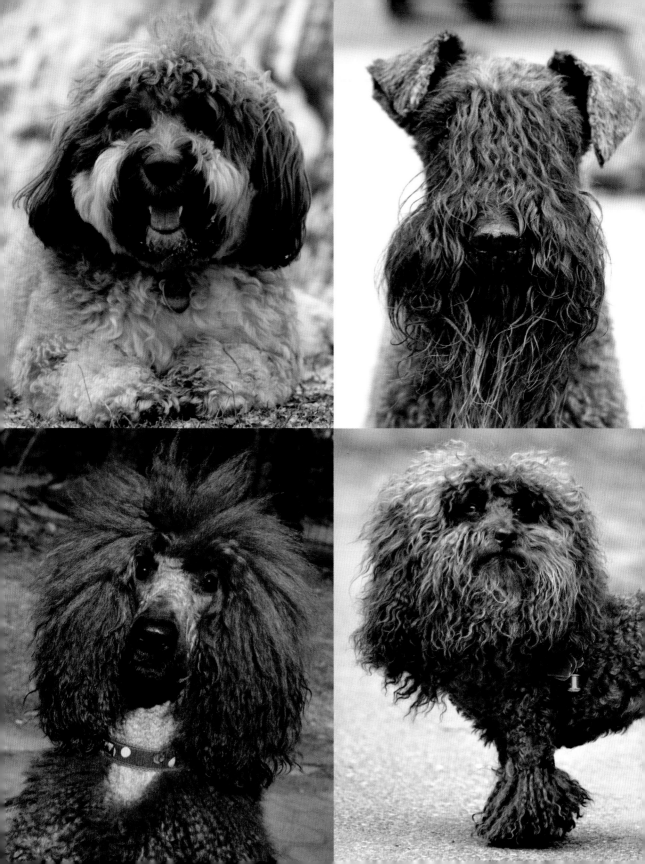

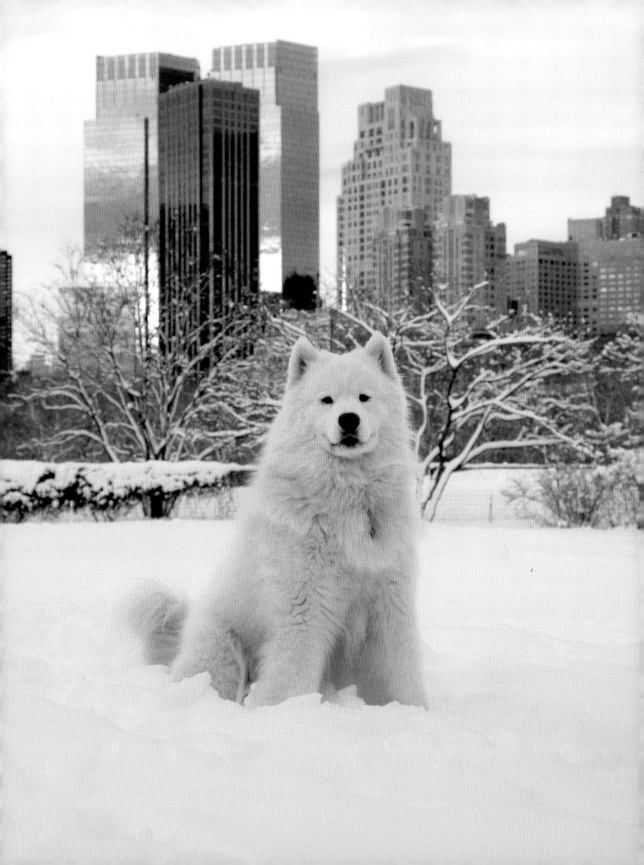

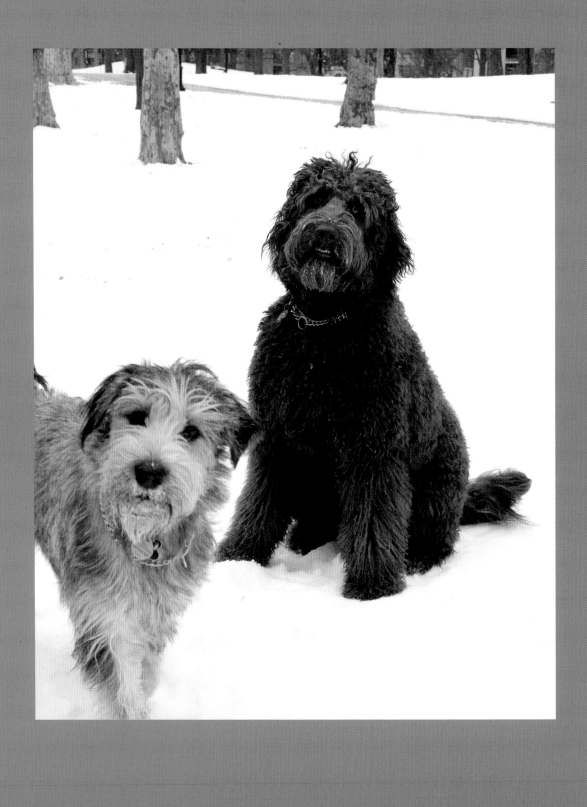

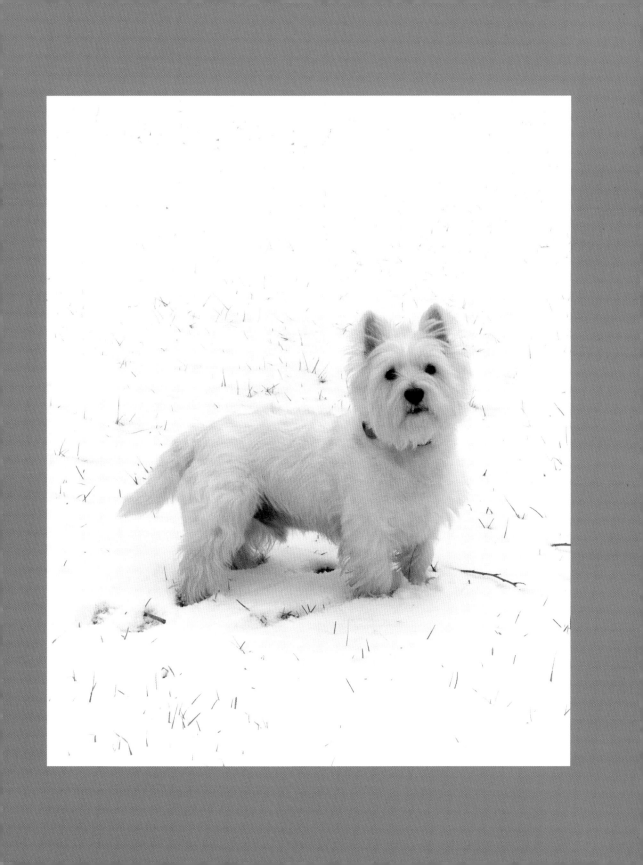

THE GREAT LAWN

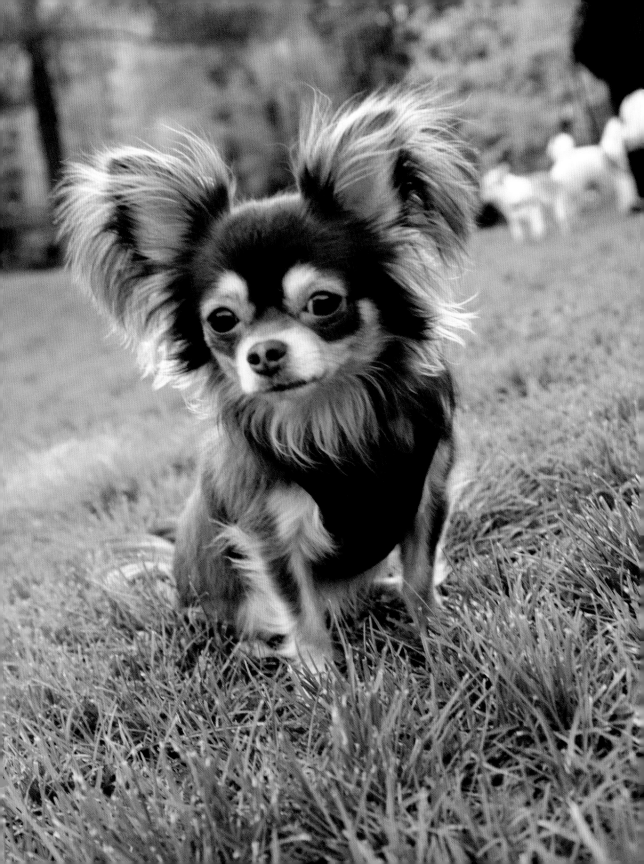

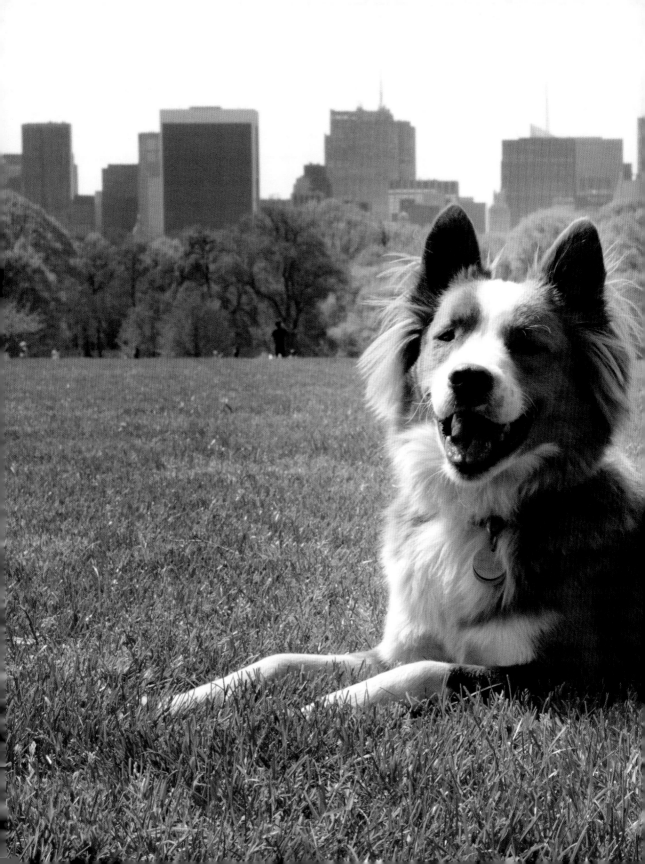

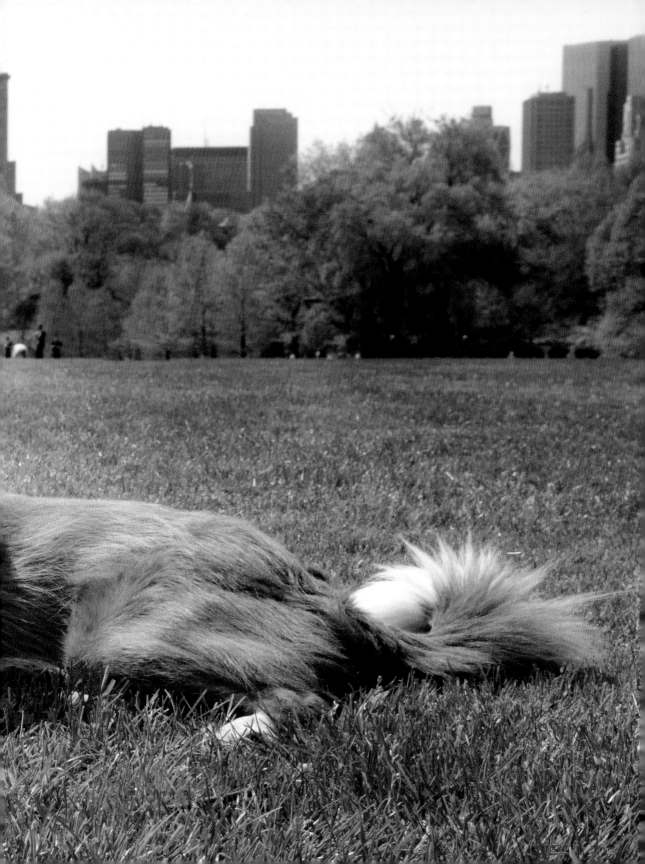

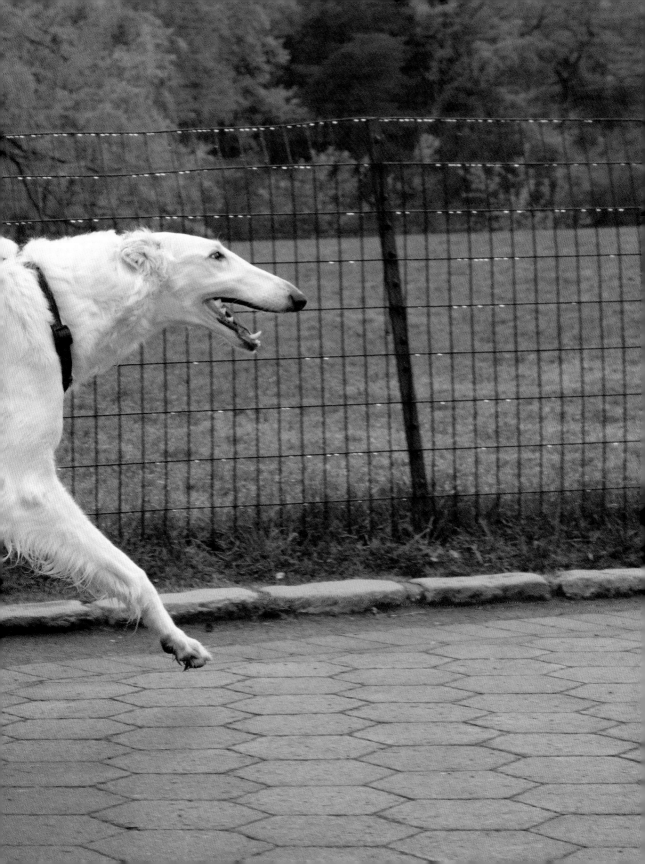

BETHESDA FOUNTAIN

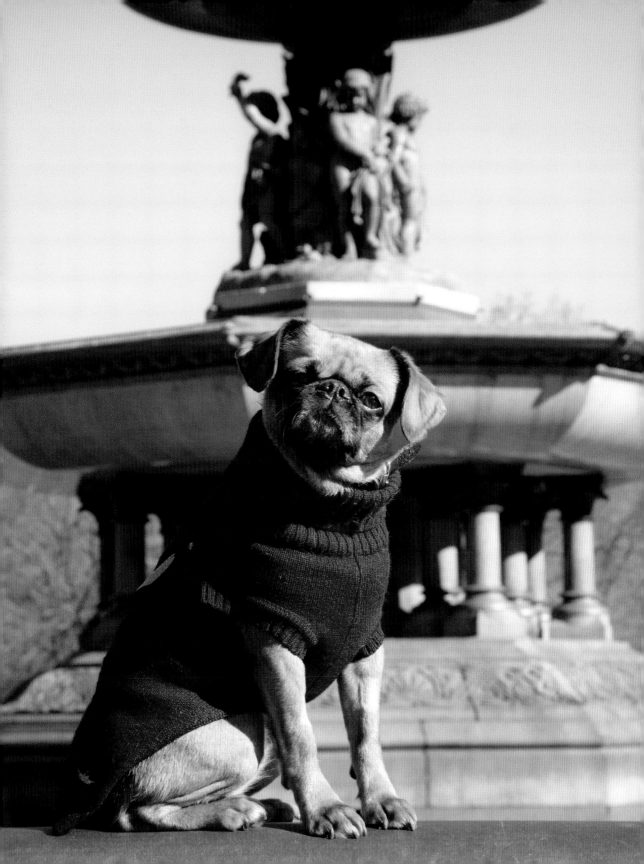

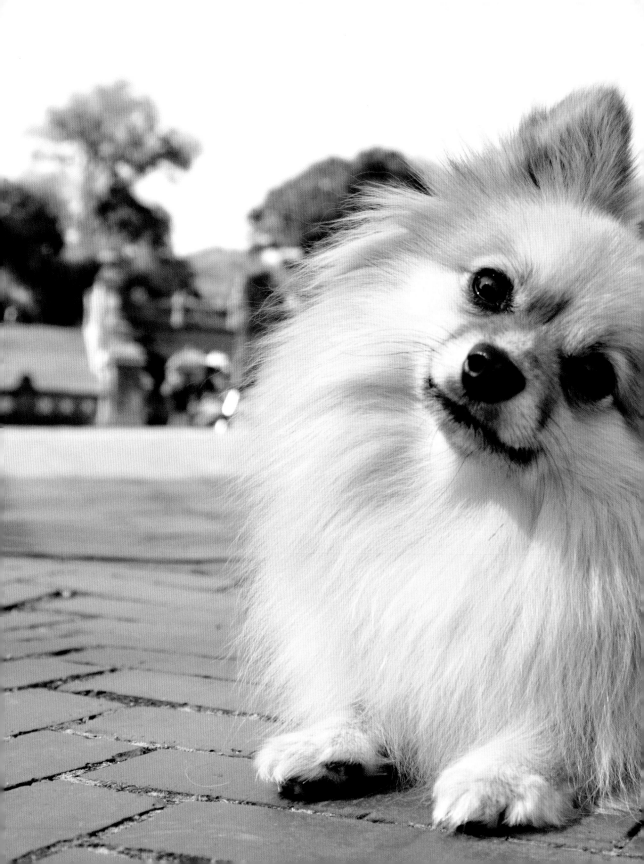

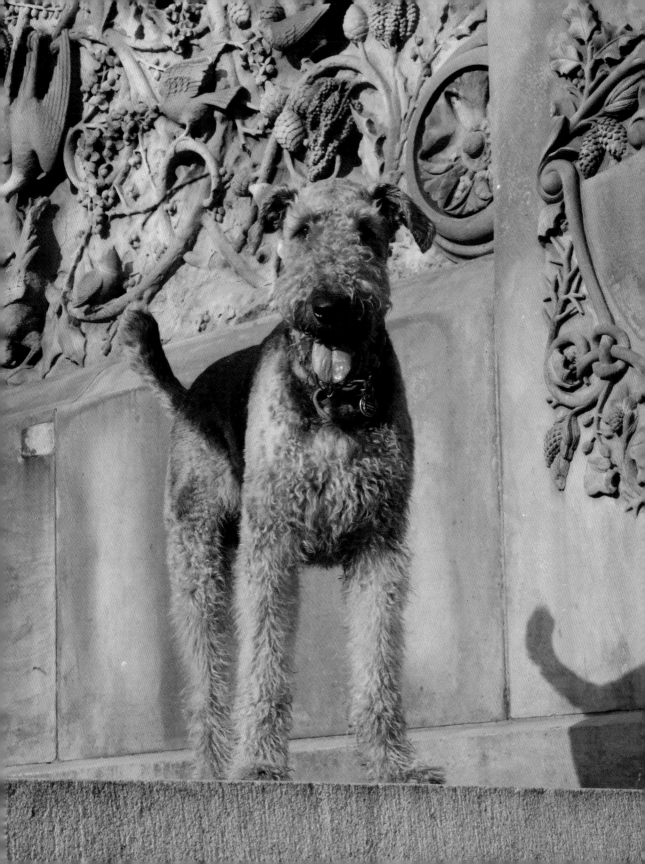

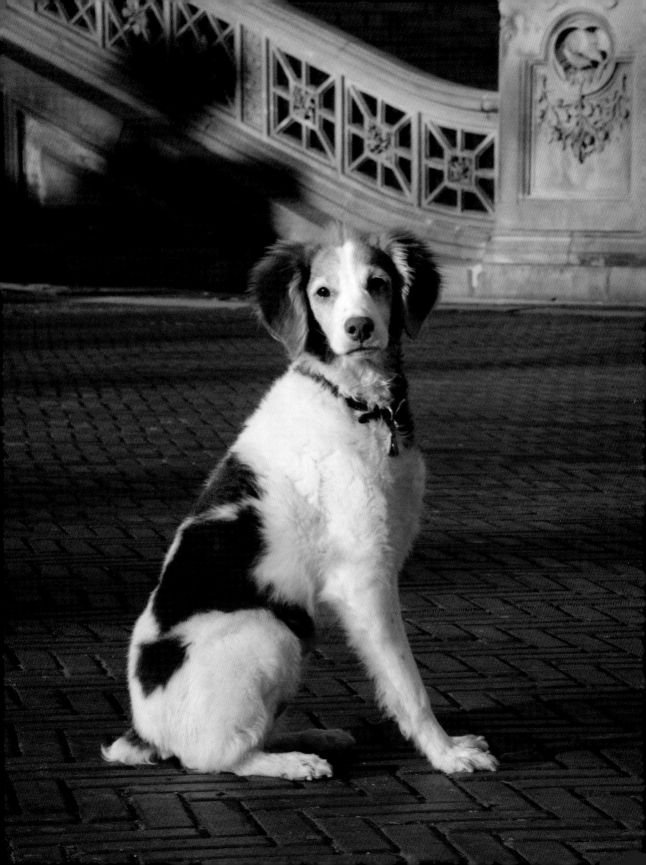

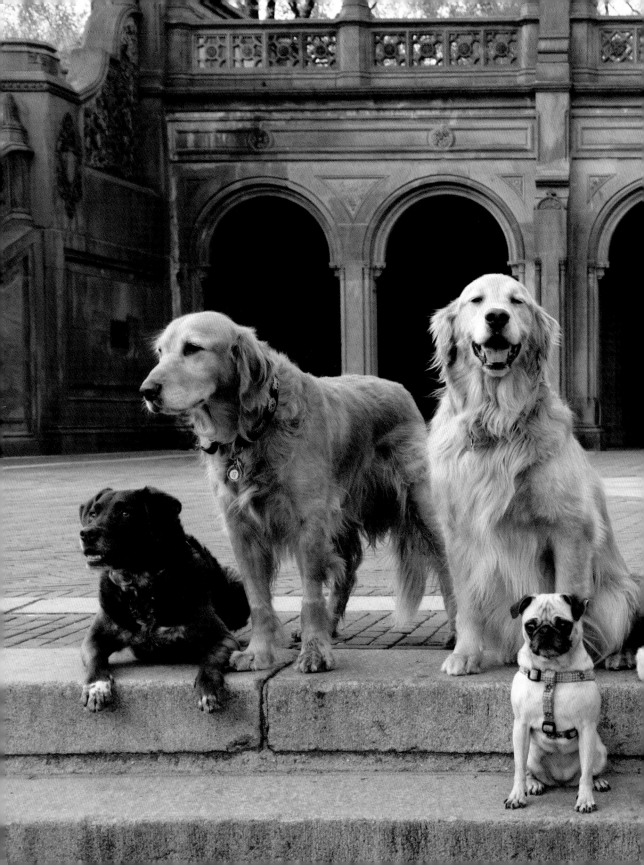

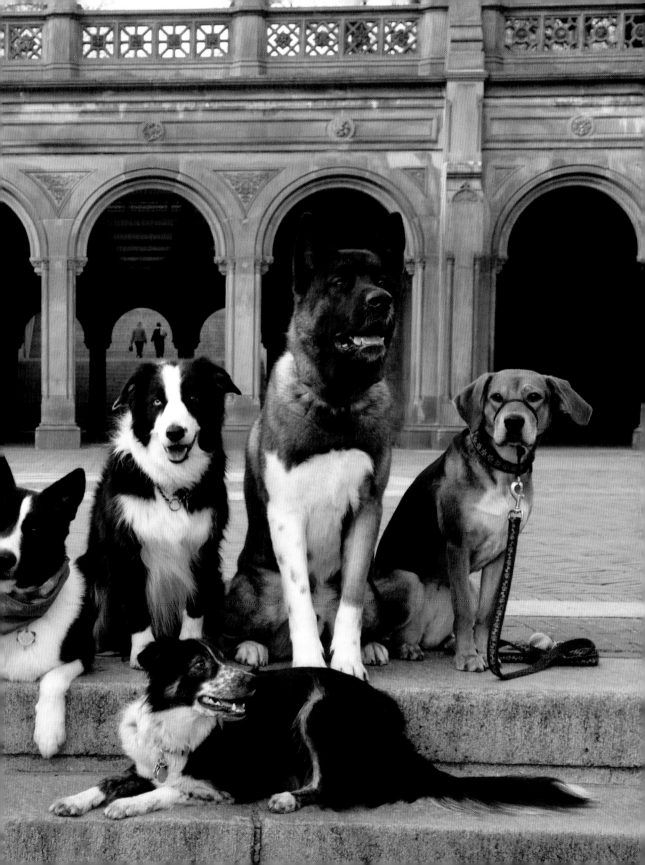

What a delight to meet the members of this happy pack *(previous page)* on the steps of Bethesda Plaza! All belong to staff veterinarians of New York's Animal Medical Center, a nonprofit academic veterinary center that has been a national leader in animal care since 1910.

Bethesda Fountain and the plaza around it is a hub for dogs and their owners. Like the Mall, it's filled with dogs rain or shine, no matter the season, and it's easy to see why. This area has some of the most beautiful architecture in the park, with several wide plazas converging at the fountain, like spokes on a wheel. Dogs climb stairs, gaze at each other across the fountain, rest on benches, dart under the lower passage, and greet each other on the plaza's stone paths.

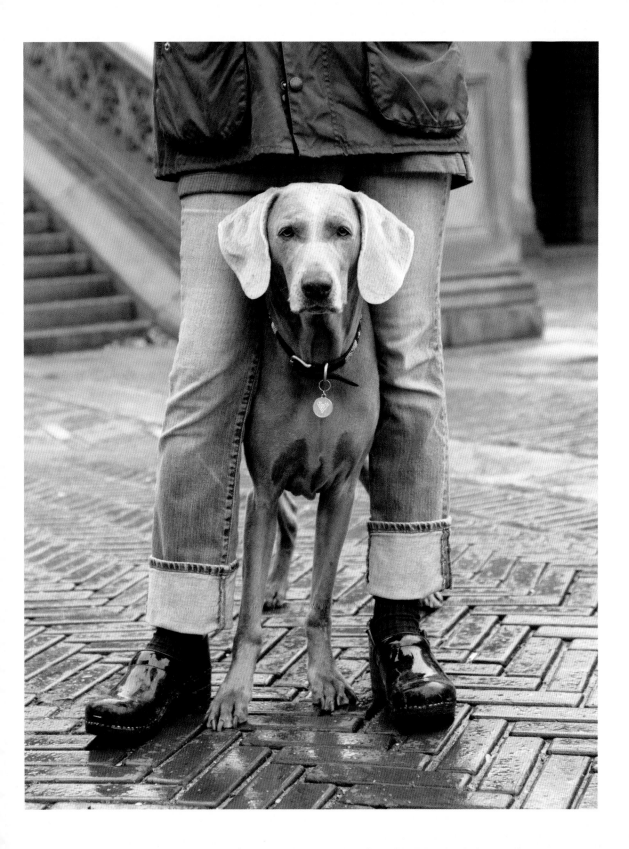

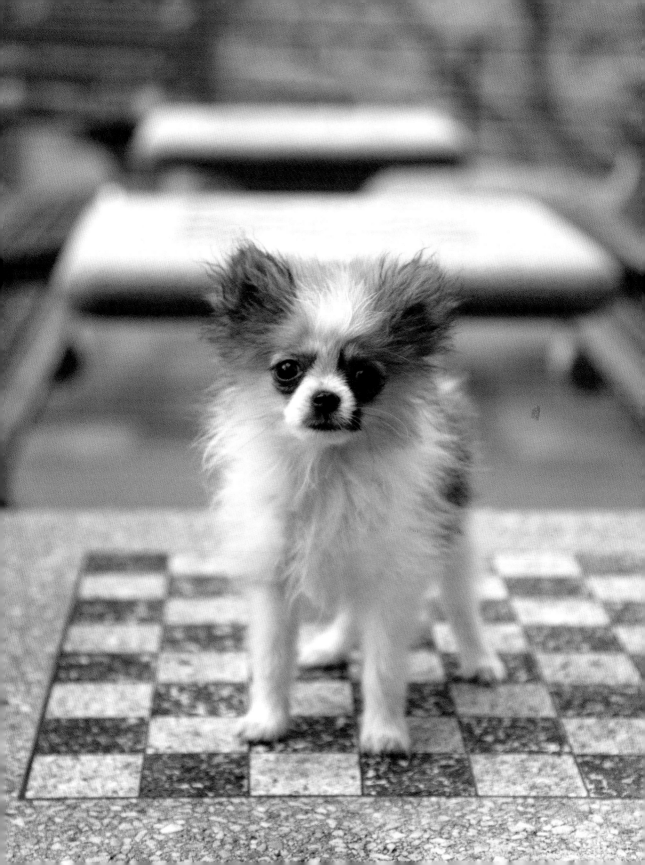

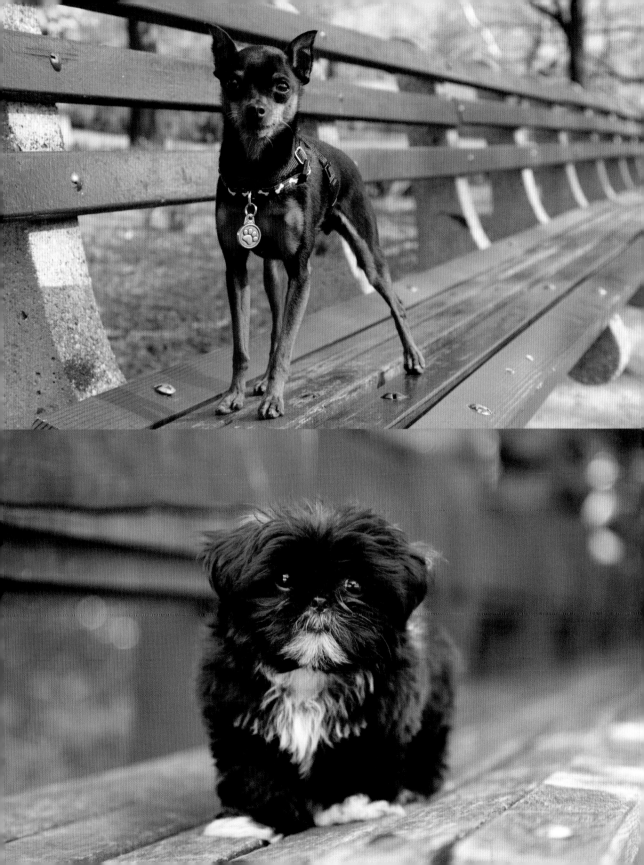

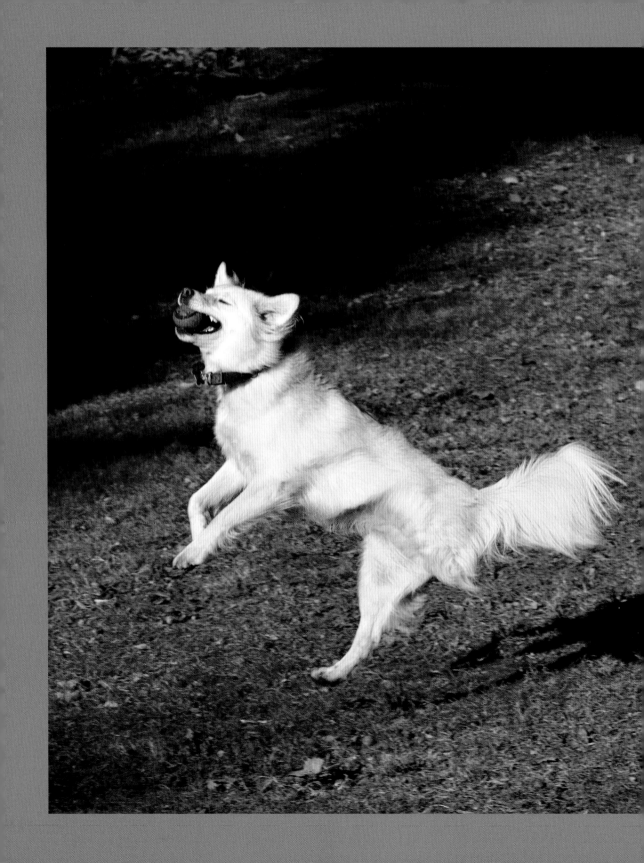

This three-legged beauty is truly an inspiration. Scheki was rescued from Israel and brought to New York City. These days, she can be found in the park, flying through the air as she plays catch with her owner for hours on end. Disabled dogs are not an uncommon site in the park, but none seem to be lacking in energy. Like every other dog here, when they get to the park, all they want to do is play!

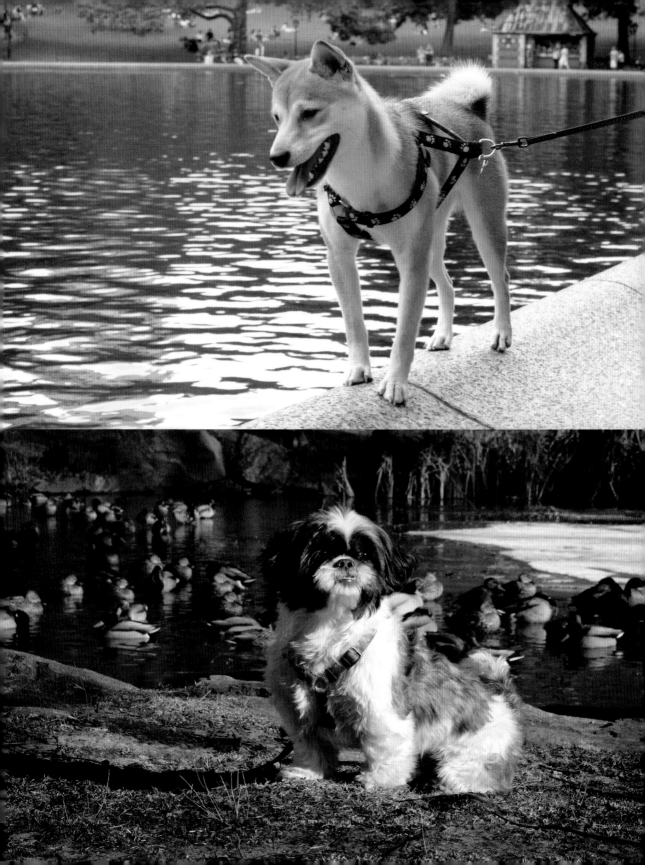

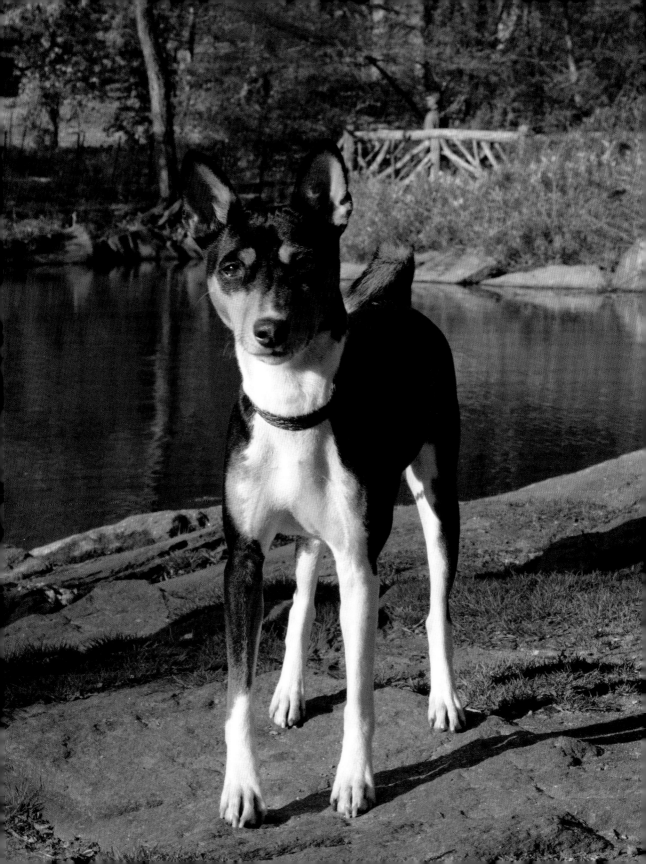

Daisy, a Husky Pit Bull mix, was rescued from the streets of the Bronx in 1998. She possesses the calmest spirit I have ever seen in a dog. With her sphinx-like demeanor and piercing blue eyes, it's no surprise that she attracts a lot of attention. An Oscar-nominated actor nicknamed her "Princess of the Moon." Roberta Flack once stopped and sang "Daisy, Daisy" to her. But Daisy doesn't get star-stuck. According to her owner, while other dogs in the park get spooked by loud noises, or chase after squirrels, Daisy can stay put on her bench for hours watching the world go by.

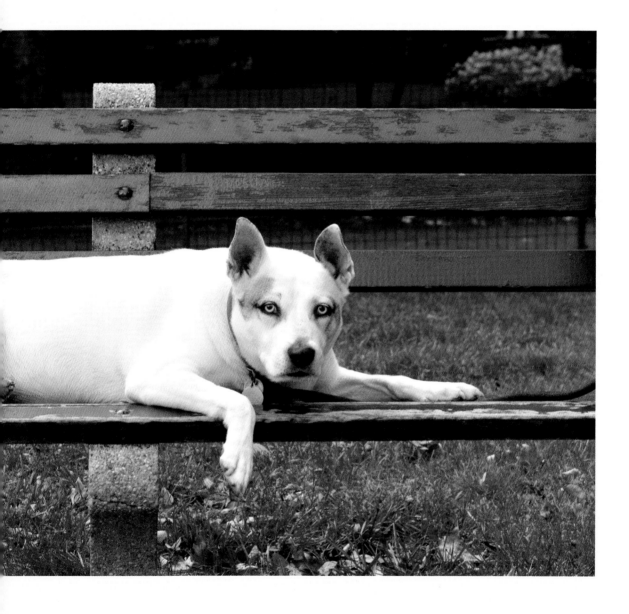

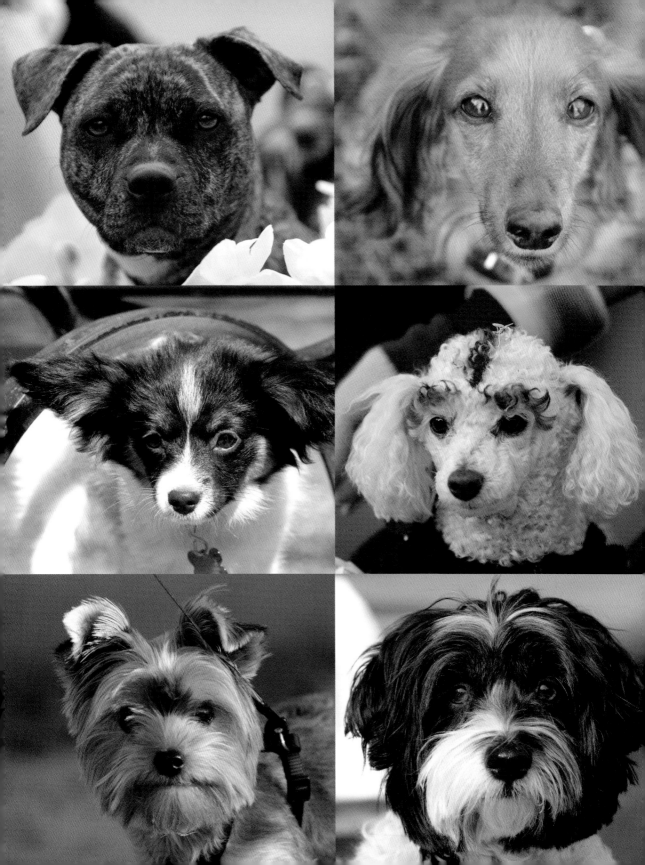

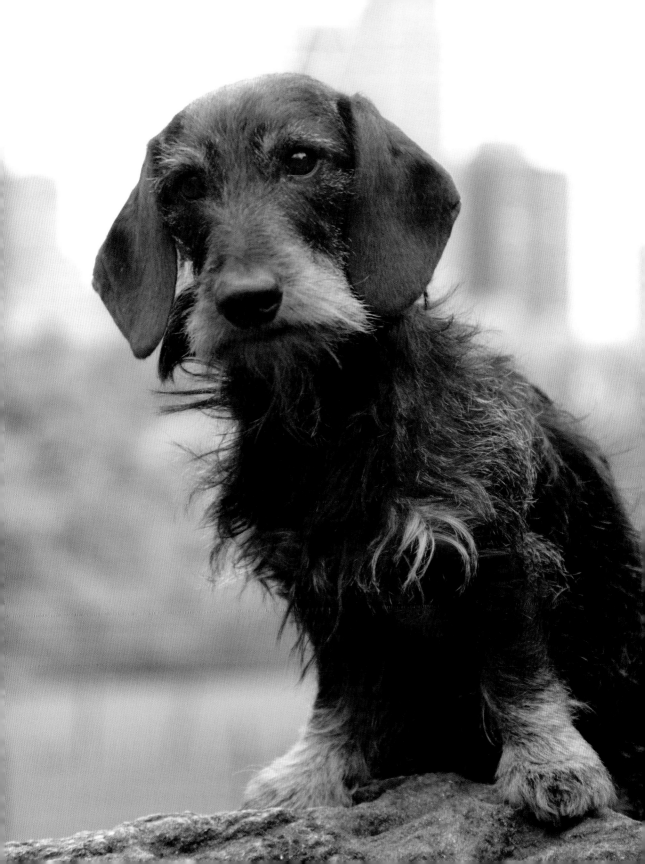

CONSERVATORY
GARDENS

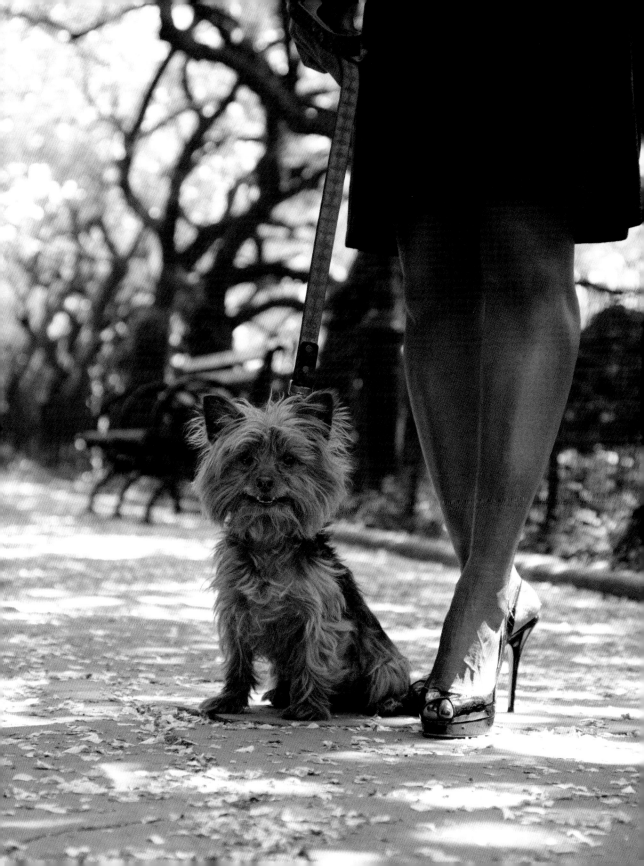

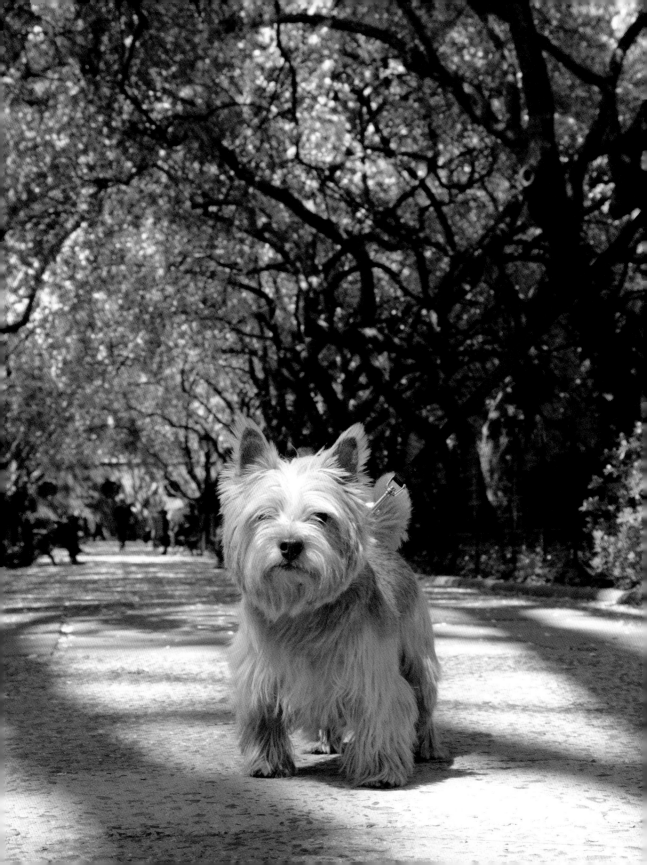

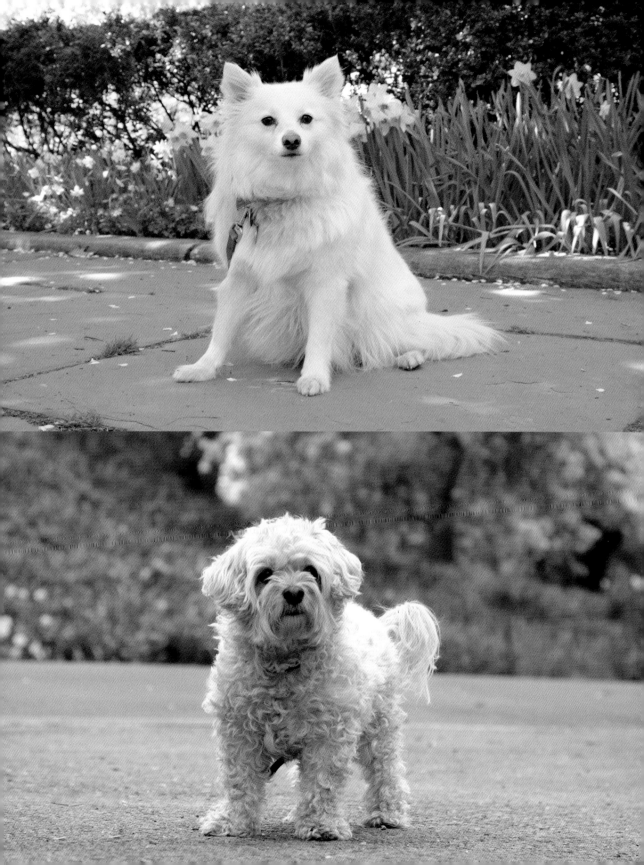

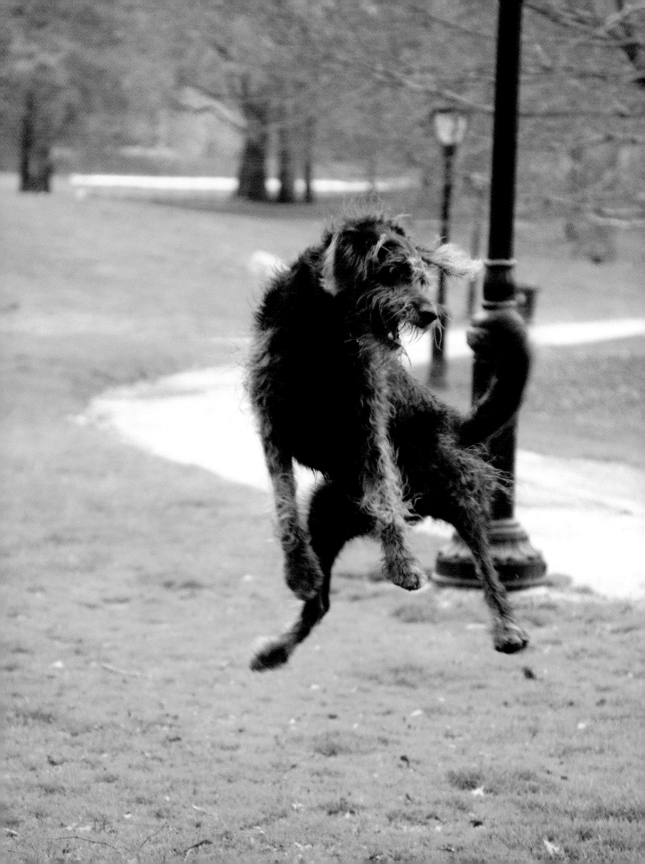

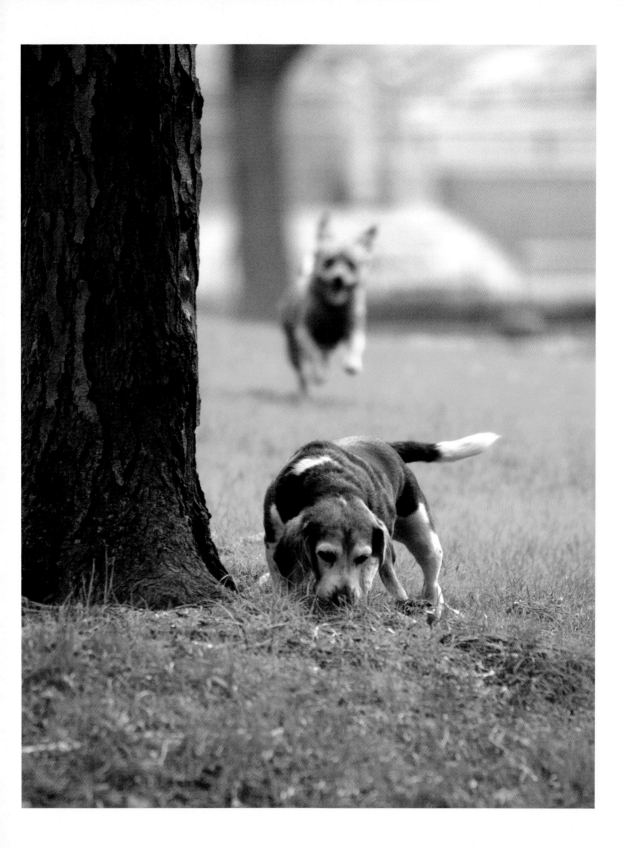

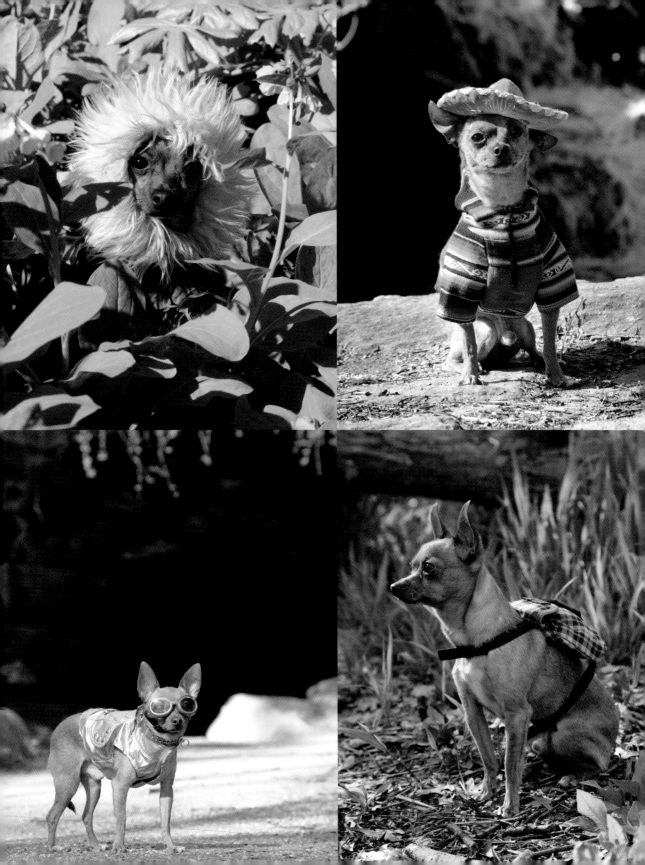

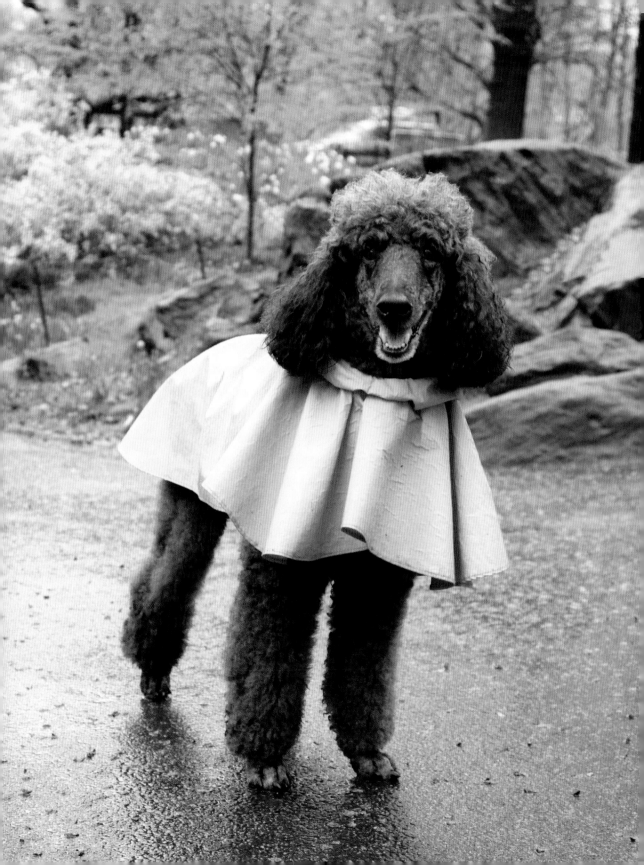

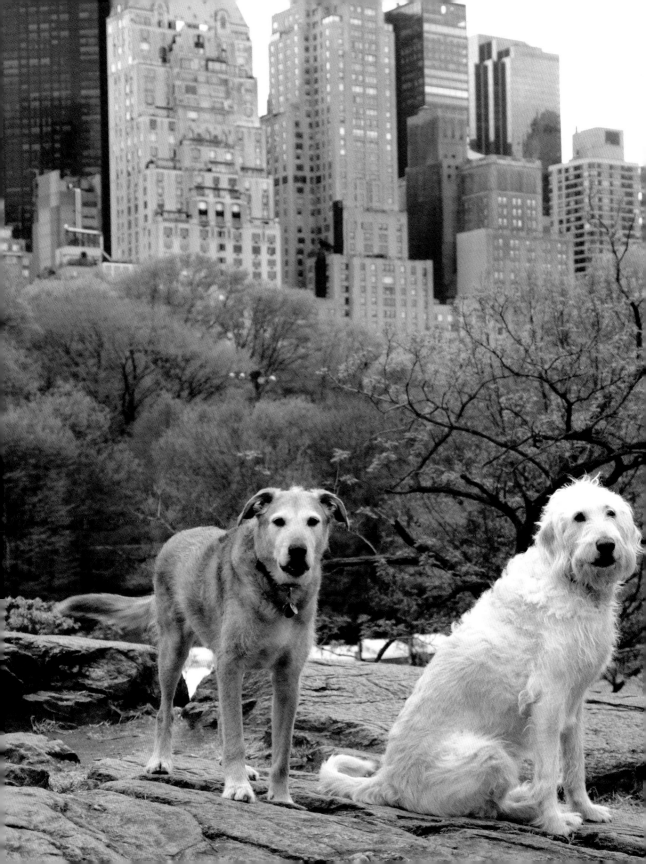

The dogs perched on the rock above Wollman Rink are Griff and Toby *(previous page)*, both Wolfhound mixes owned by the veterinarian Andrew Kaplan. Dr. Kaplan saved Toby *(left)* from a city shelter where he had been deemed unadoptable. The experience motivated Kaplan to found the Toby Project, a nonprofit organization that spays and neuters dogs in communities around New York City for free.

Peaches *(opposite)* is a five-year-old Shetland Sheepdog. It was clear when we met behind the Metropolitan Museum of Art near the Obelisk, that she was enjoying that place in the sun, but according to her owner she loves herding her friends and chasing squeaky toys in all corners of Central Park.

The beautiful confluence of purebred and mixed breed dogs that frolic in the park is something that many passers by comment on—but to the dogs, everyone is just another potential playmate, someone to run to, bark at, or chase around.

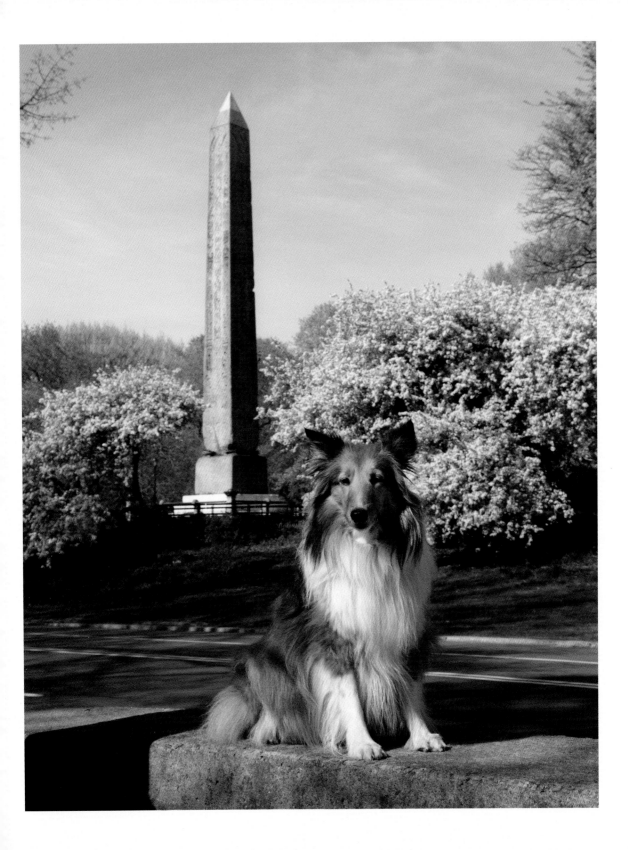

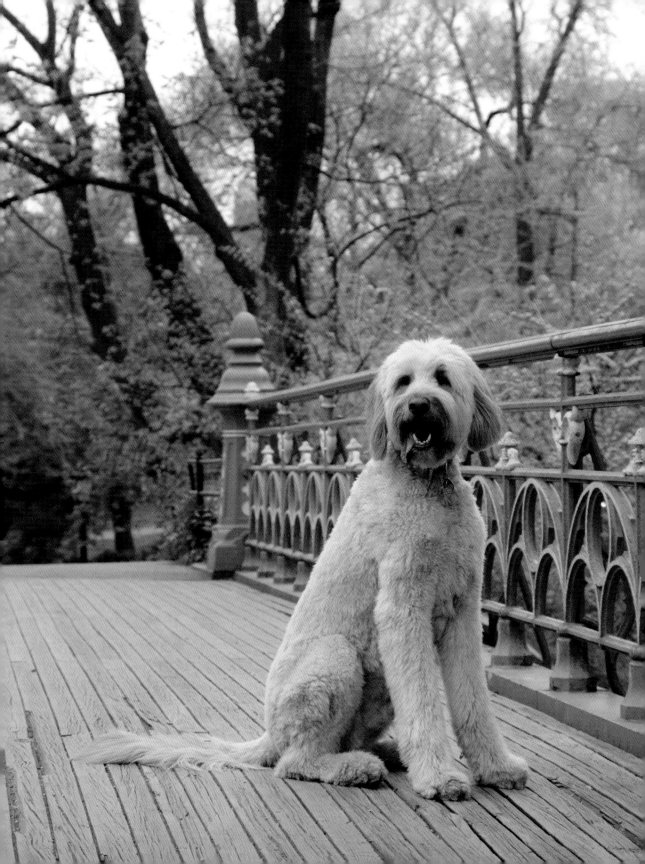

THE LAKE

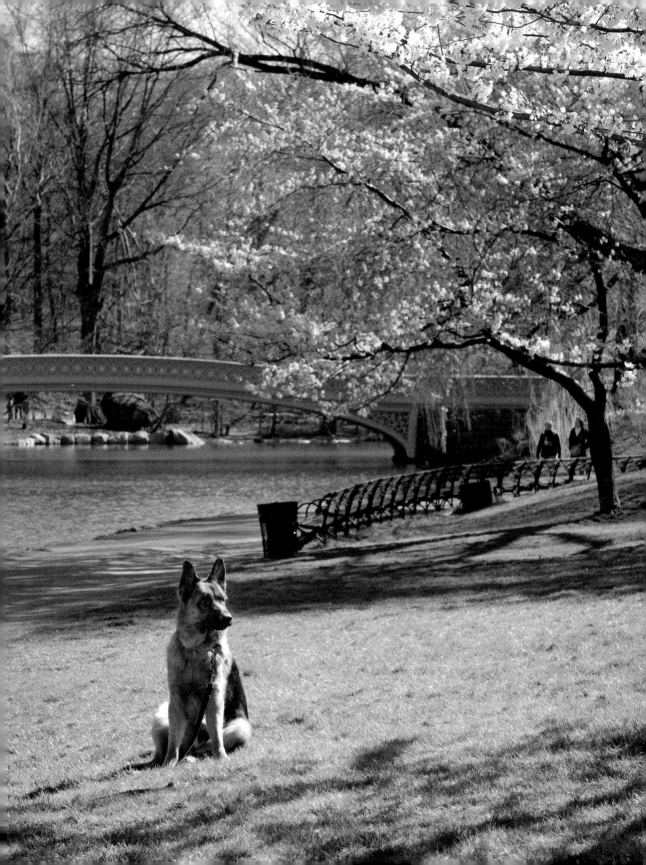

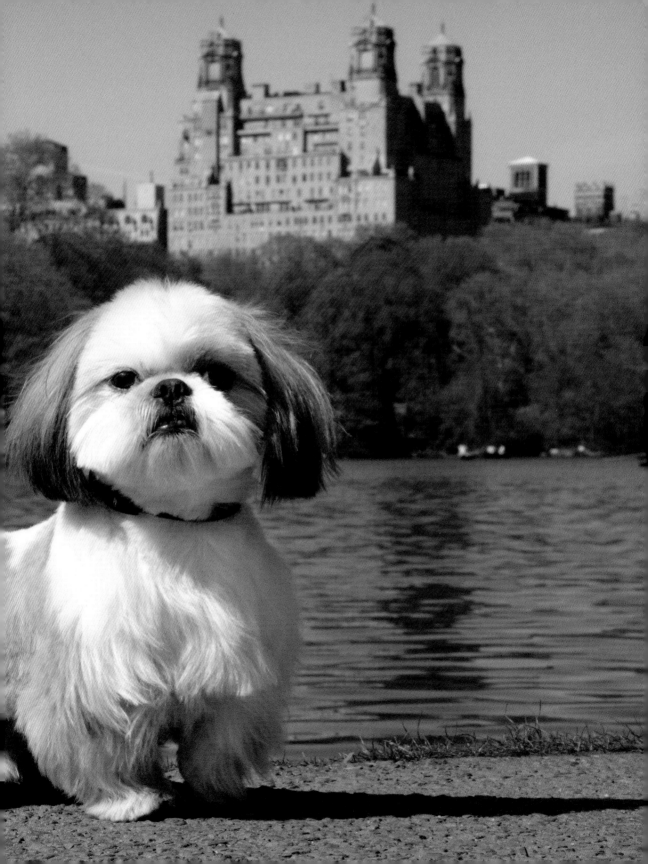

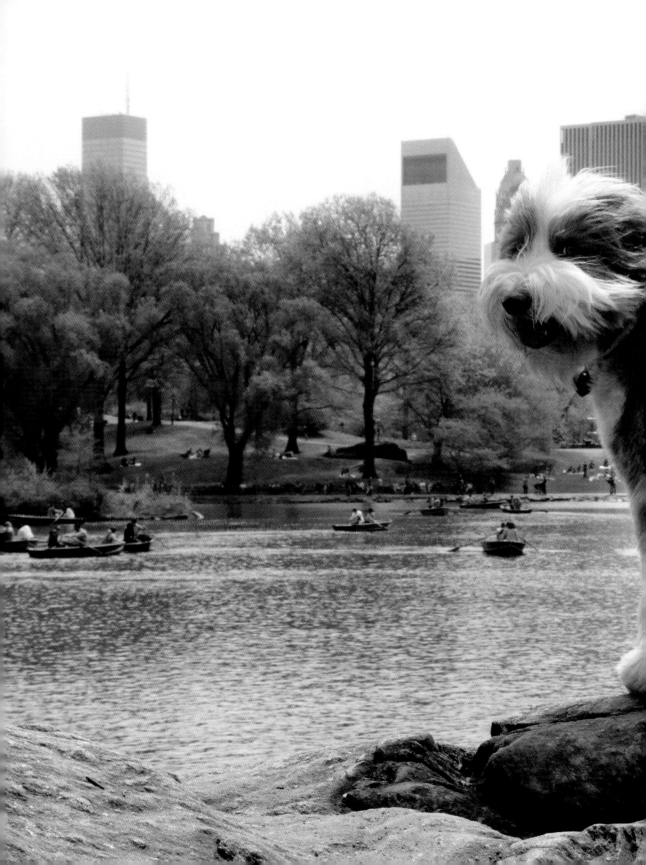

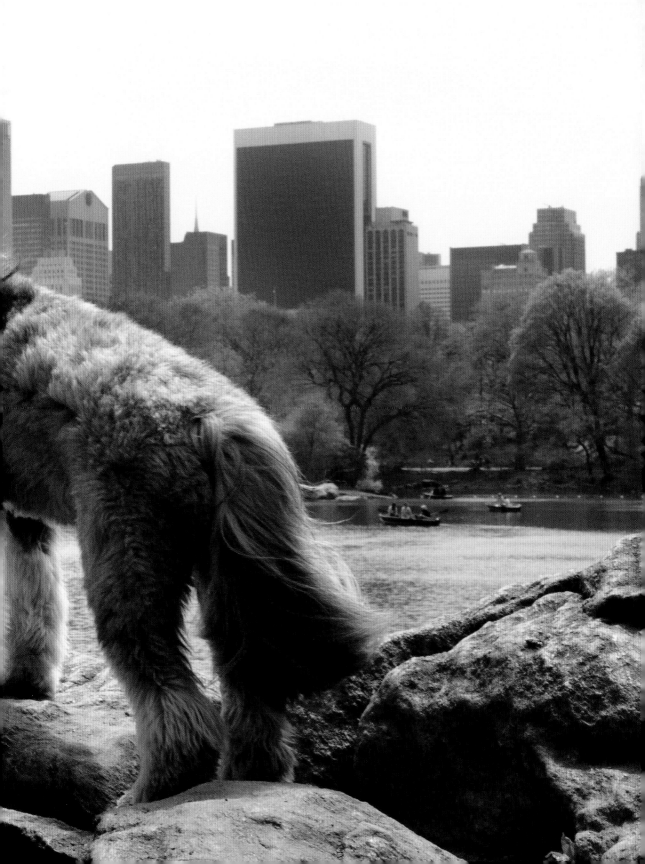

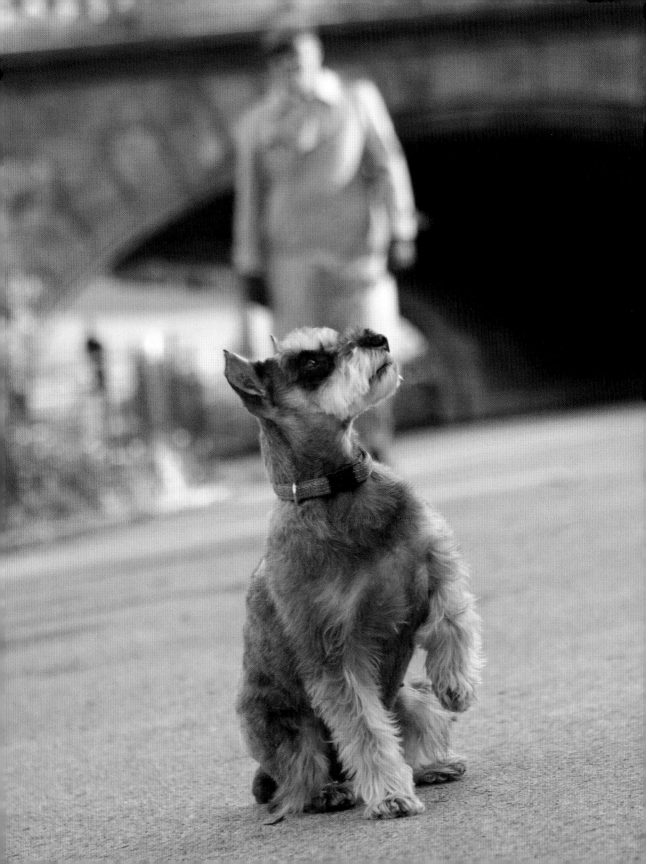

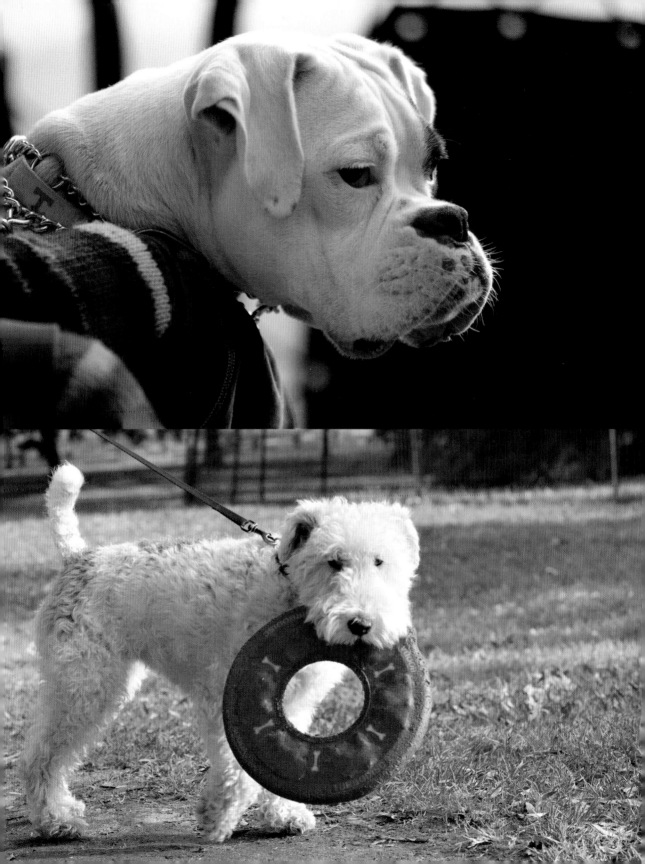

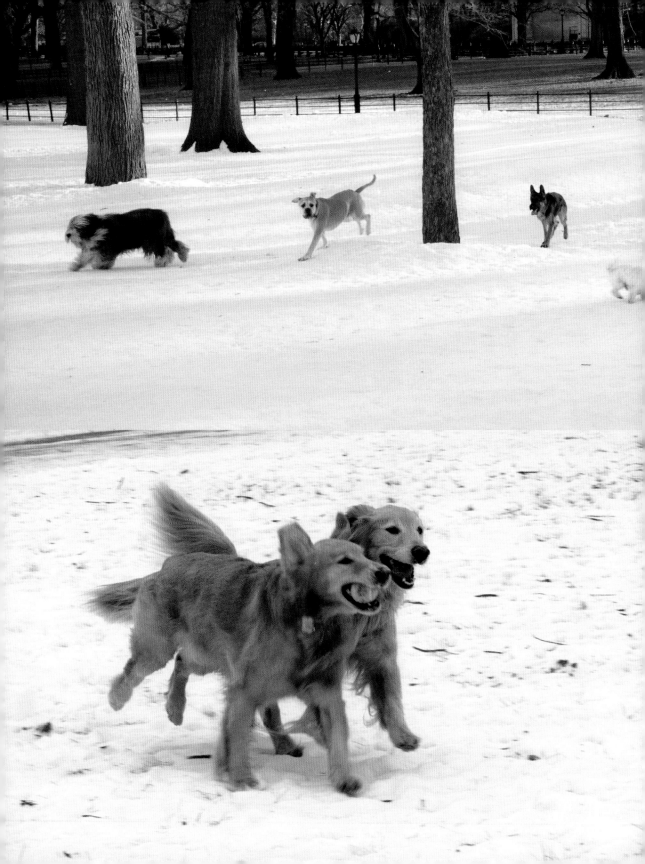

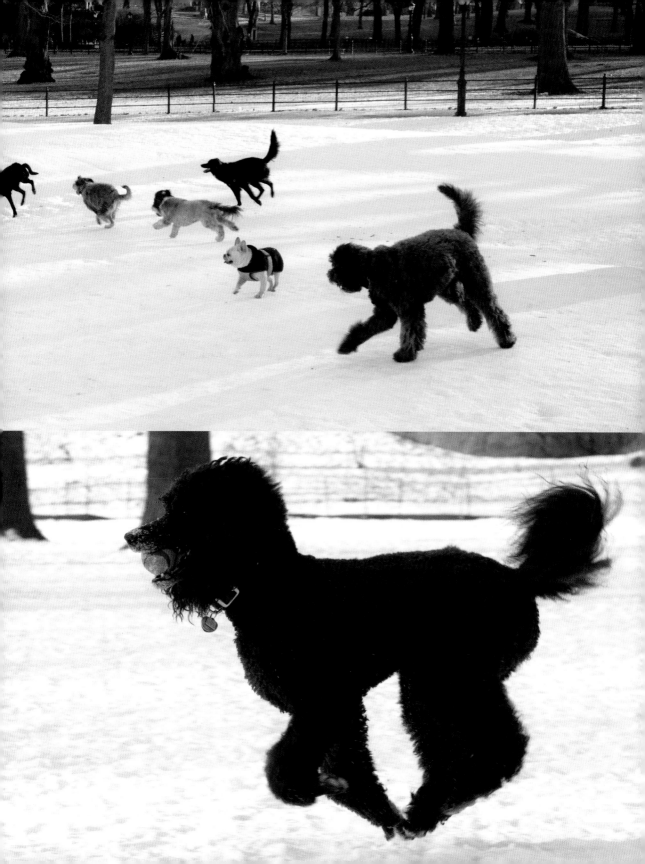

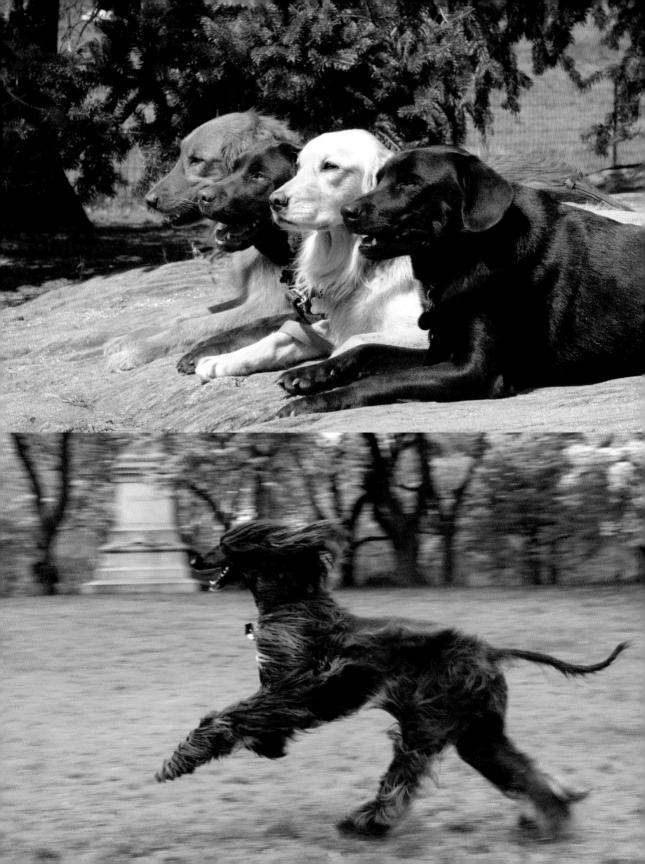

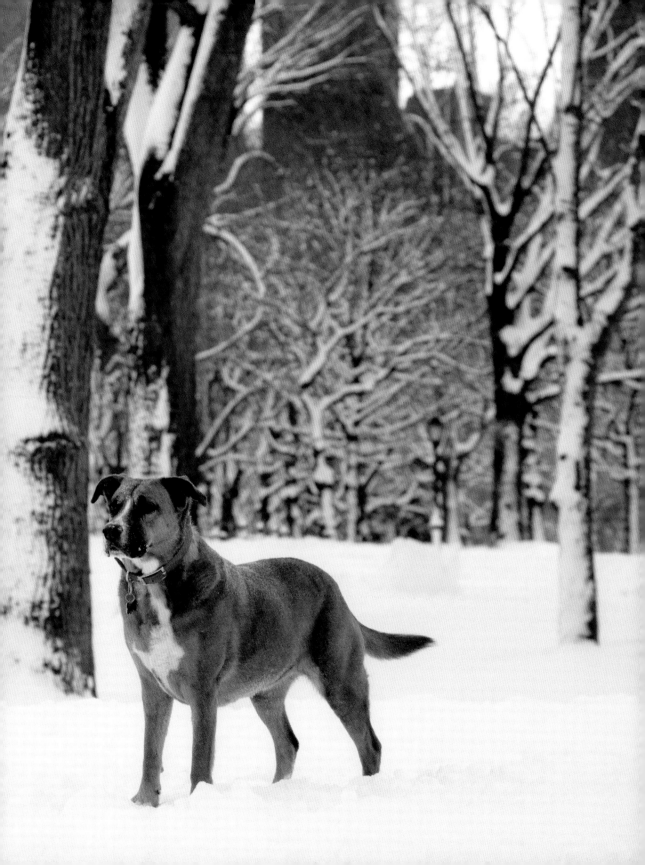

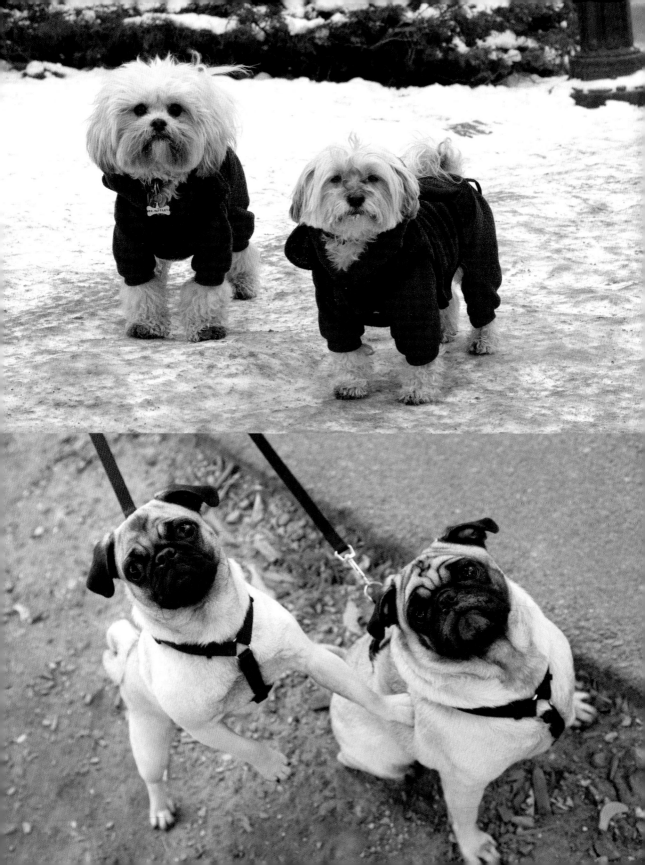

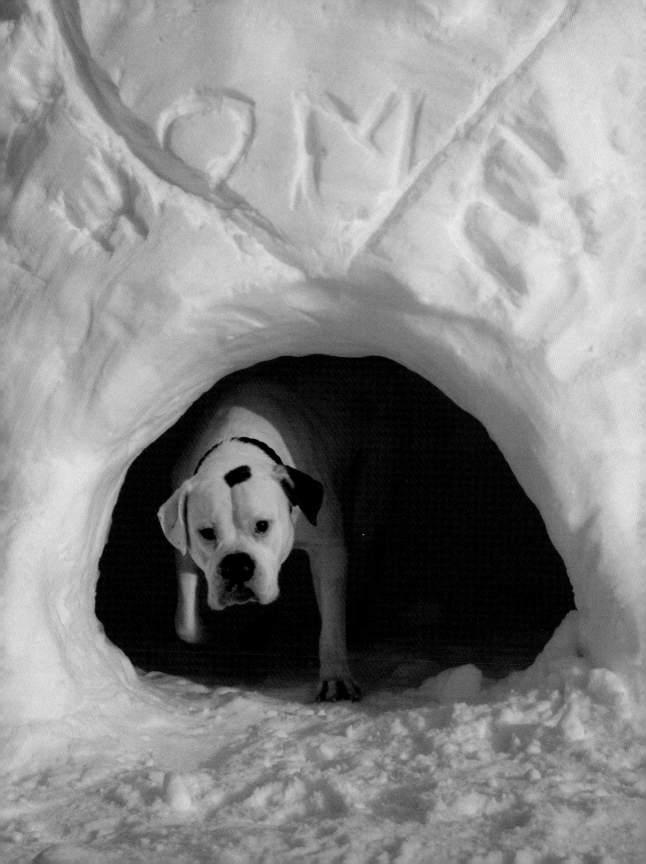

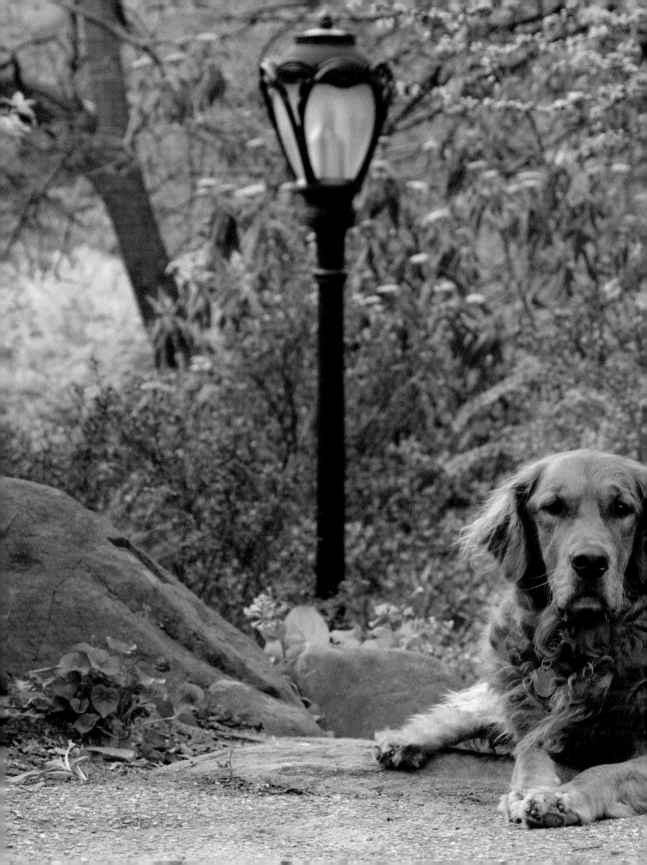

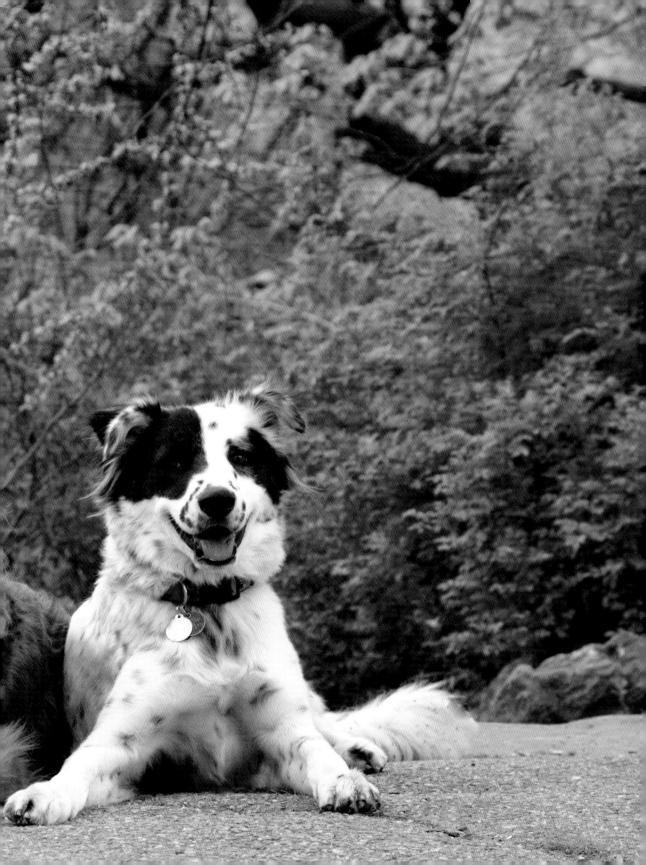

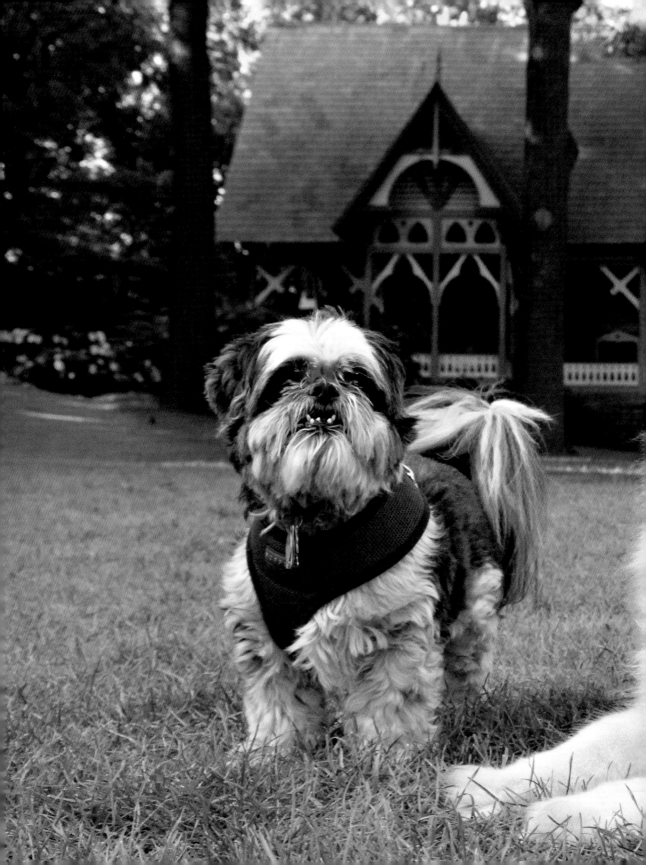

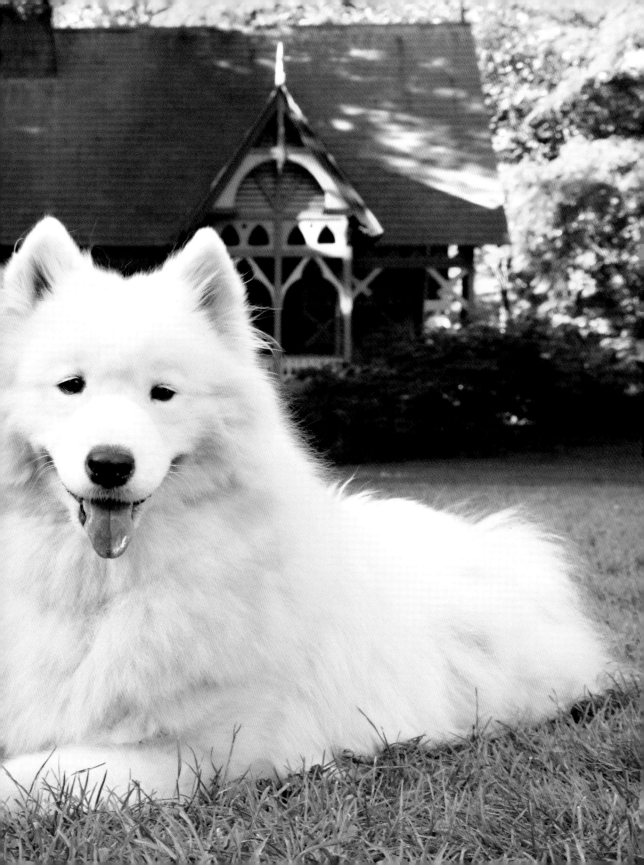

Parts of Central Park are always full of activity, especially on glorious spring and fall days, but there are some calmer places where dogs can stop for a quiet moment in between games of fetch. The lawn below the Dairy is one of those places, and it was here that I met Mojo, a Shih Tzu (*previous page, left*), and Diva, a Samoyed (*previous page, right*), an "Odd Couple" both adopted by the same owner. Though they are as different as can be, according to their owner, they live together very peacefully.

Sacha (*opposite*) is the daughter of Zeus, once the top Newfoundland in the country. A typical "Newfie," Sacha is like a child when it comes to water: she loves splashing through every puddle, pond, and stream she sees. When she's tired herself out, she and her owner retreat to the Wisteria Pergola, a spot of refuge by the Bandshell.

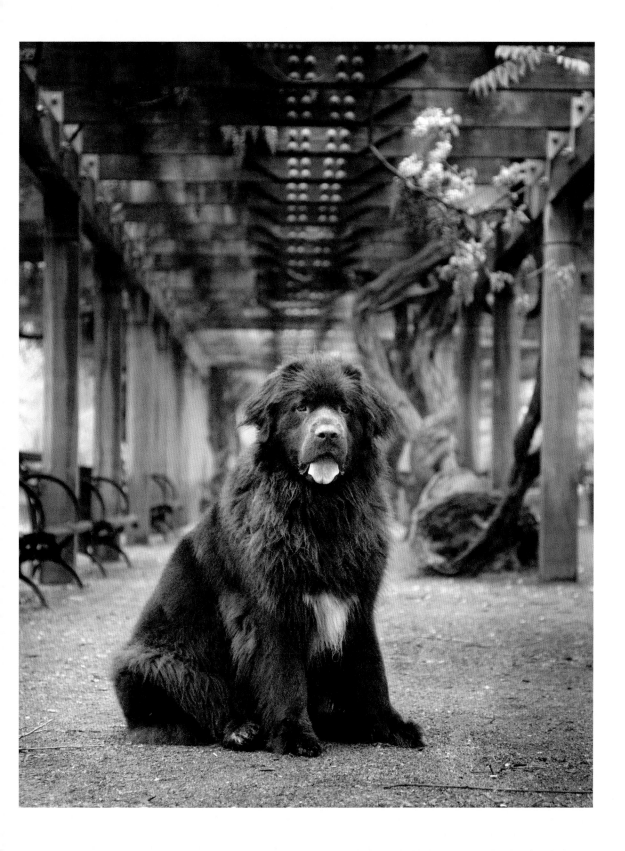

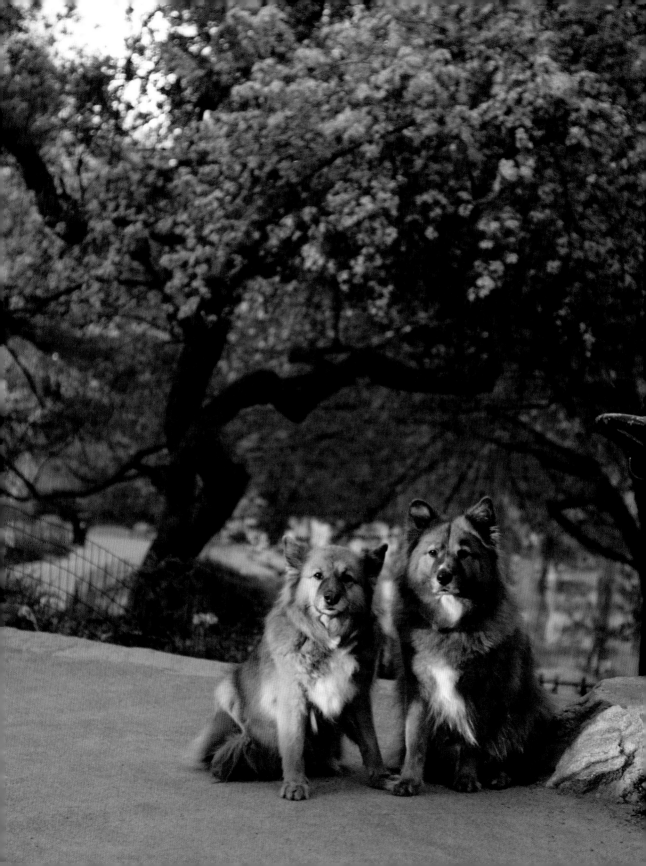

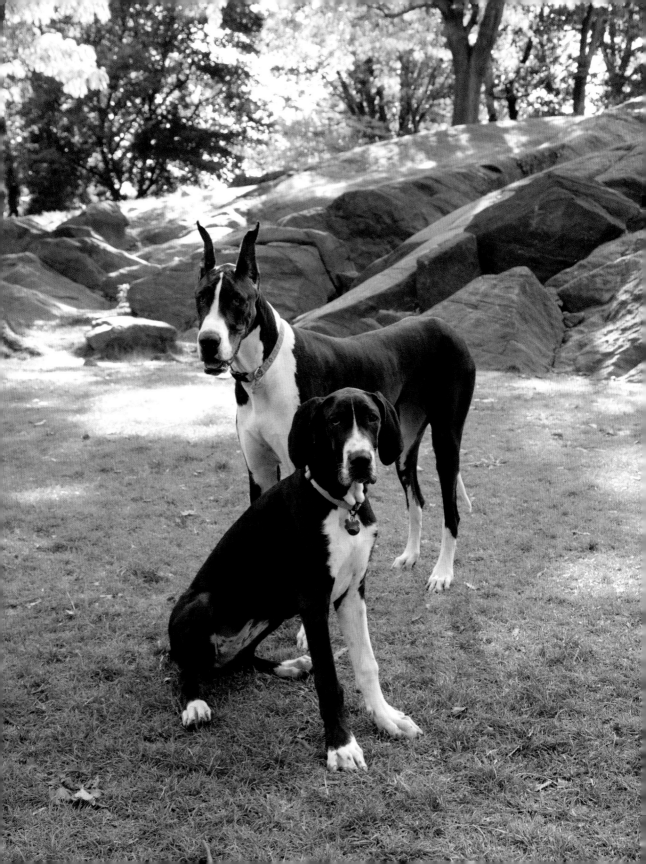

CEDAR HILL

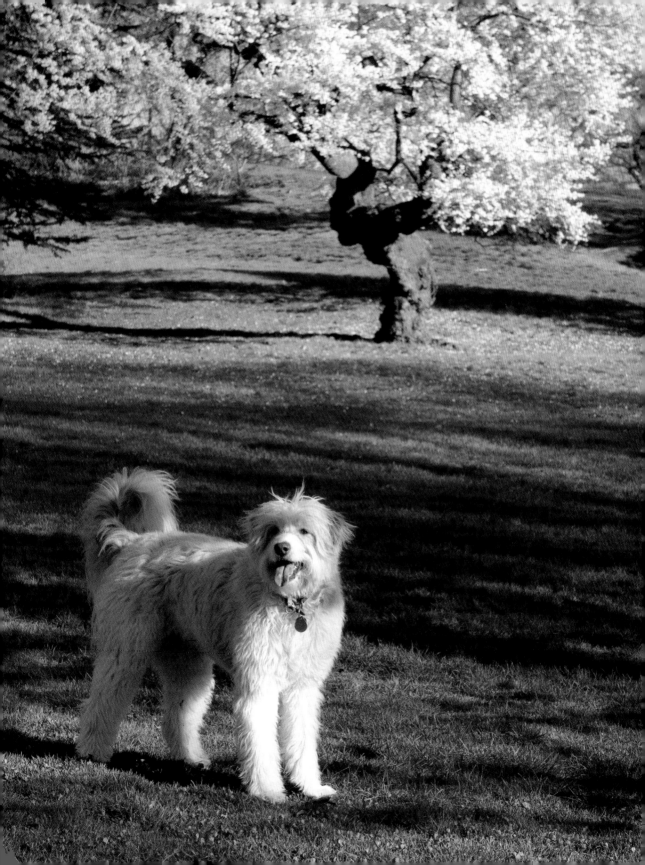

Between 9 PM and 9 AM, dogs are allowed to be off leash in most of Central Park. During these hours, dogs that politely greet each other like neighbors while on leash can be seen bounding through every corner of the park in packs and chasing each other with unbridled enthusiasm. As their dogs frolic, owners chat, share coffee, and swap stories about their pets (and, as the minutes creep close to 9, nervously check their watches). They know one another principally in relation to each other's animals, and thanks to their dogs, they are part of a happy little community within the big city.

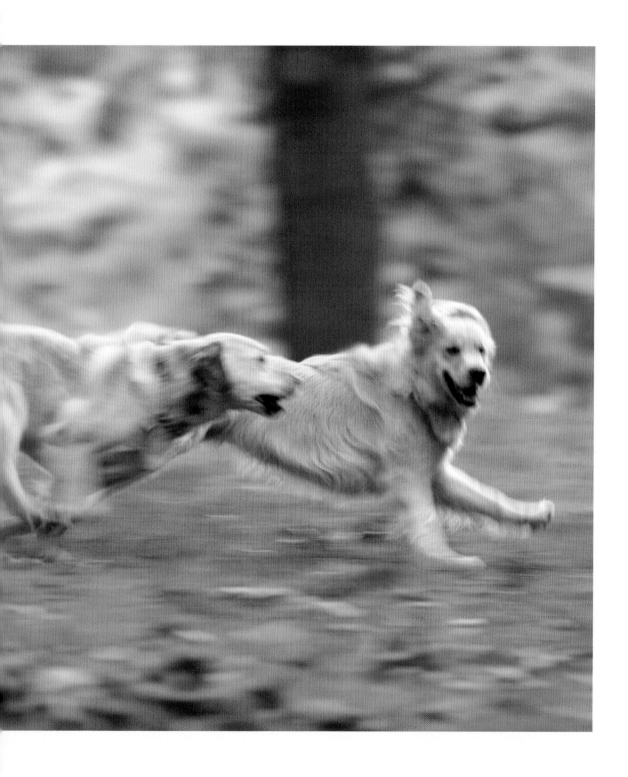

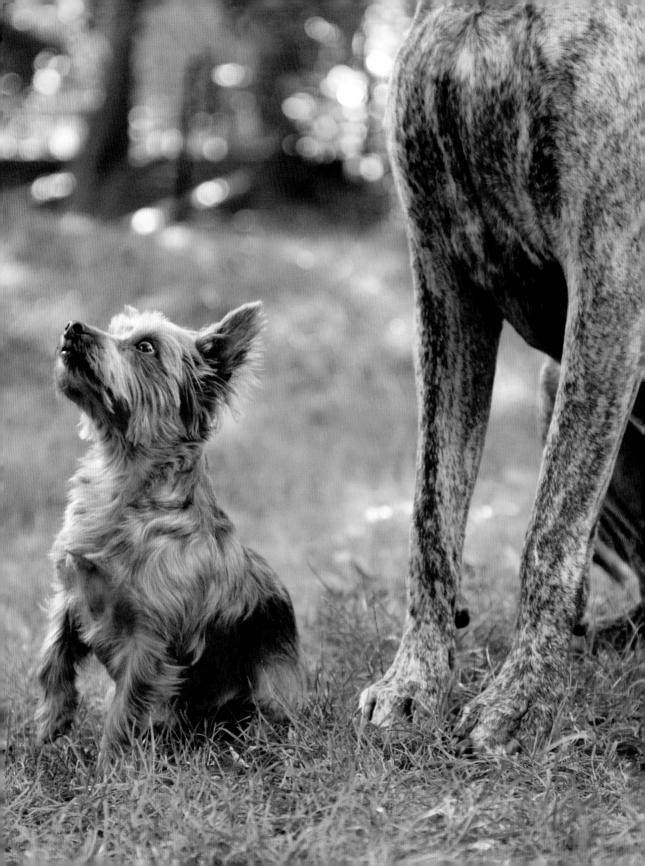

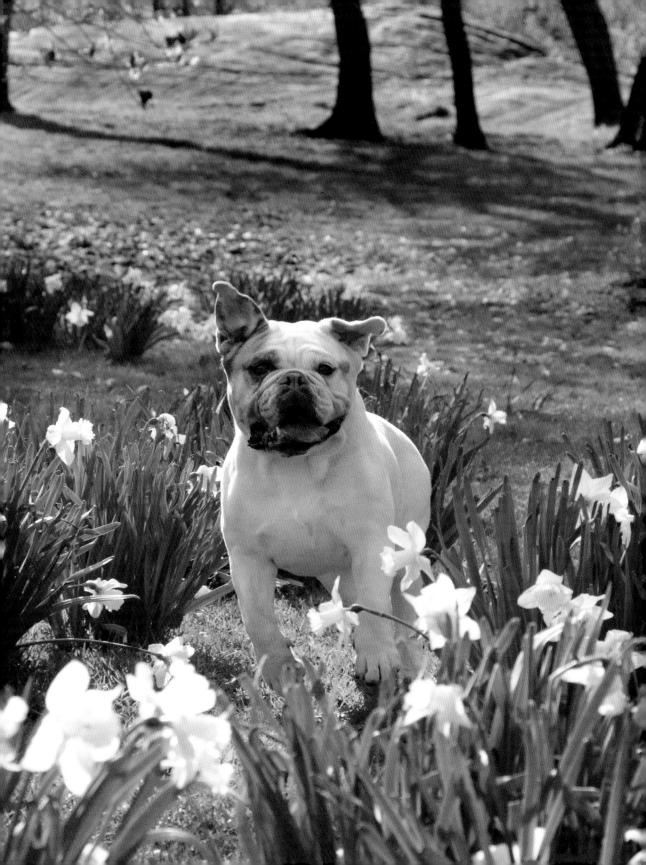

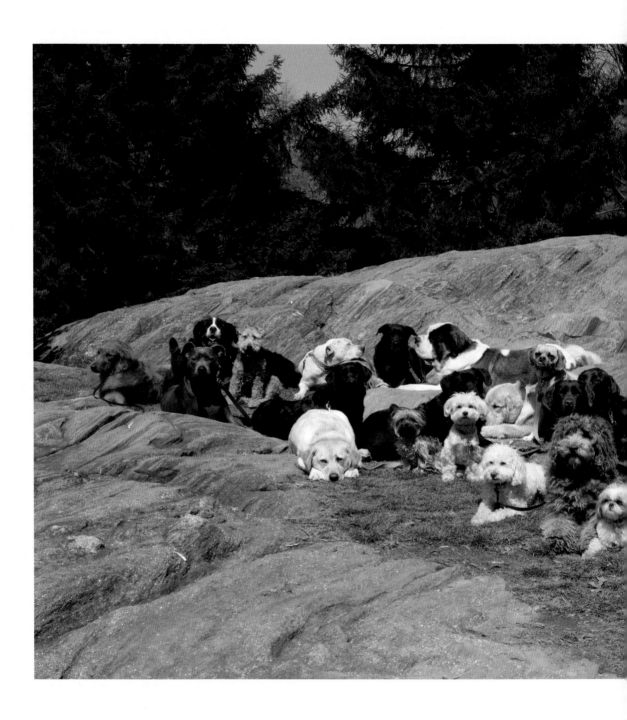

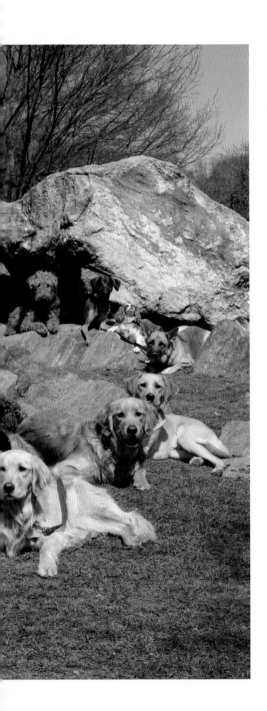

It wouldn't be possible to write a book on the dogs of Central Park without mentioning the dog walkers. Every day, dozens of dog walkers venture into the park with their charges, sometimes making multiple visits a day. Some walk only one or two dogs at a time, while others bravely command groups of multiple dogs from all different owners. This especially large group always turns heads. Led by trainer Tibor Feigel of Zen-K9, this "variety pack" of dogs exudes an air of peace and harmony.

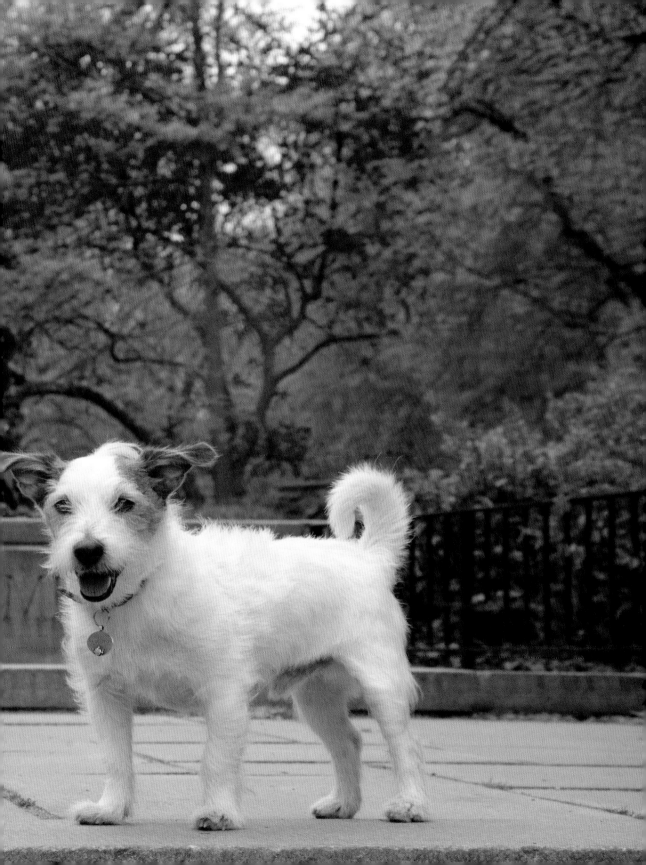

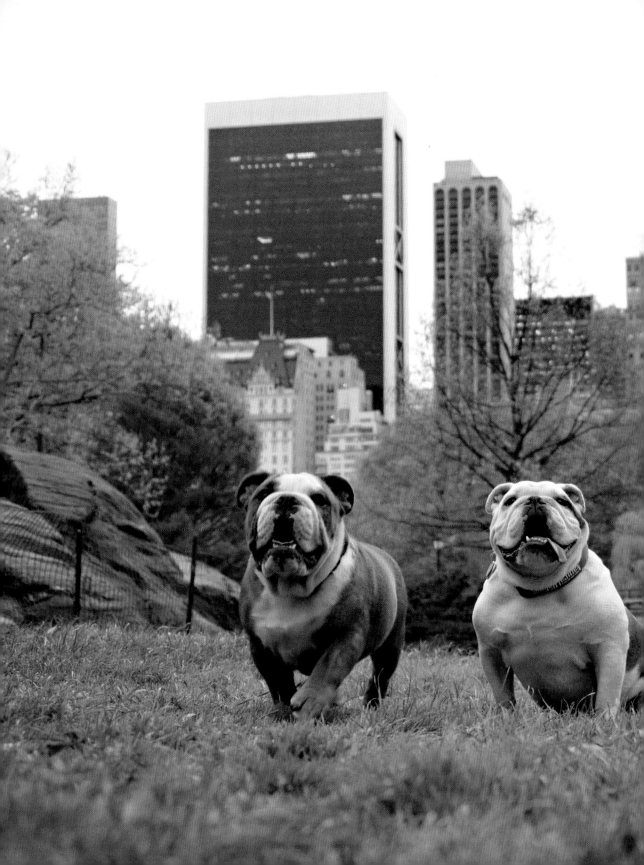

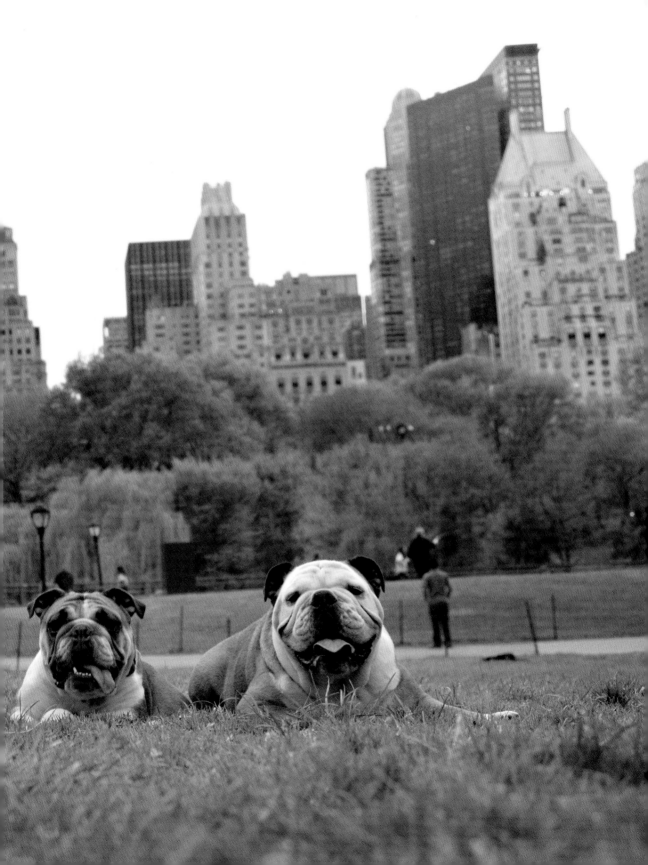

FIRST PUBLISHED IN THE UNITED STATES OF AMERICA IN 2010 BY

UNIVERSE PUBLISHING

A division of Rizzoli International Publications, Inc.

300 Park Avenue South, New York, NY

www.rizzoliusa.com

PHOTOGRAPHY © 2010 Fran Reisner

PUBLICATION © 2010 Universe Publishing

2010 2011 2012 2013 2014 / 10 9 8 7 6 5 4 3 2 1

PRINTED IN CHINA

ISBN: 978-0-7893-2212-8

LIBRARY OF CONGRESS CATALOG CONTROL NUMBER: 2010942289

DESIGNED BY Sara E. Stemen

ABOVE: Fran pictured with her dogs, Sadie and Jazzy.
PHOTO BY BRANDI CARRERA.

THIS BOOK would not have been possible without the help and encouragement of several special people, and to them I must give thanks: To my dear friend Brandi Carrera, who was by my side during the start of this journey and remained in spirit the rest of the way, I thank you for being there. To my daughter, Elissa, who listened with patience to my endless stories about the dogs before finally experiencing them with me; thank you for tolerating my travels and for being a constant source of inspiration. Thank you also to my agent, Linda Langton, for shoring me up and giving me guidance; it was fate when we met that cold winter day in the park. It has been a delightful experience capturing the images of these dogs and having conversations with their owners, and so I thank you all for allowing my intrusion, sharing your stories and your dogs, and inspiring me all the more.